P9-EDT-902

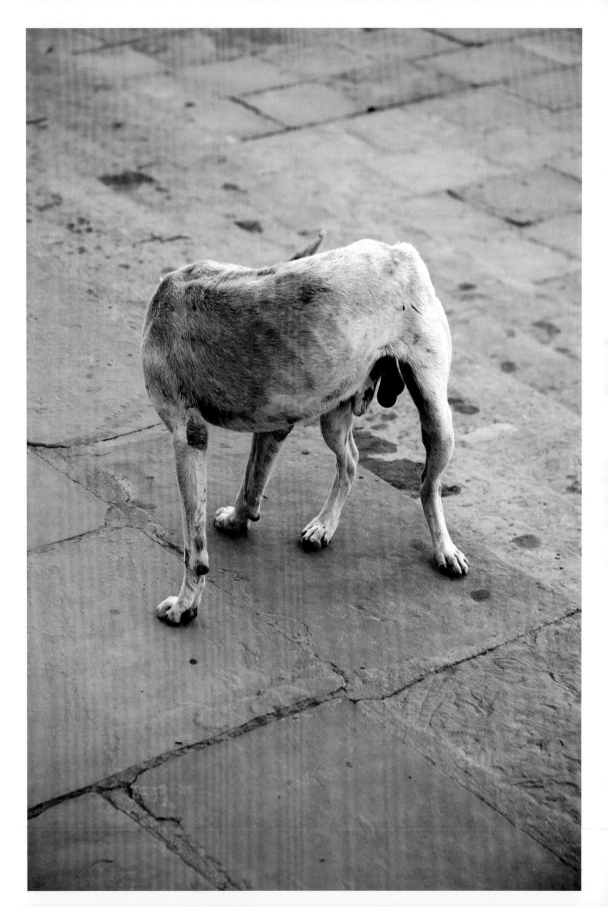

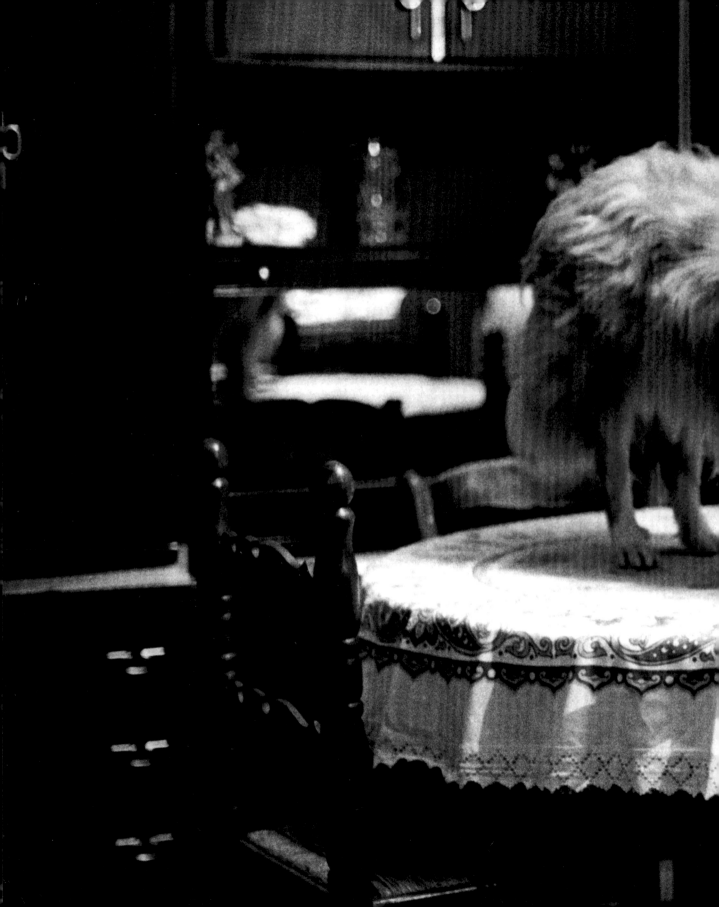

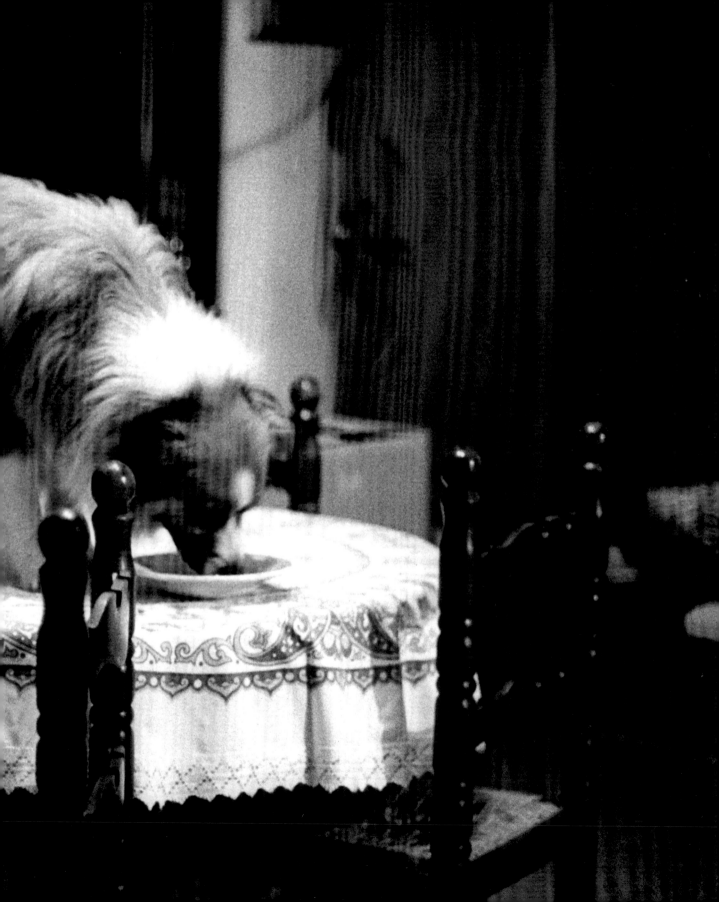

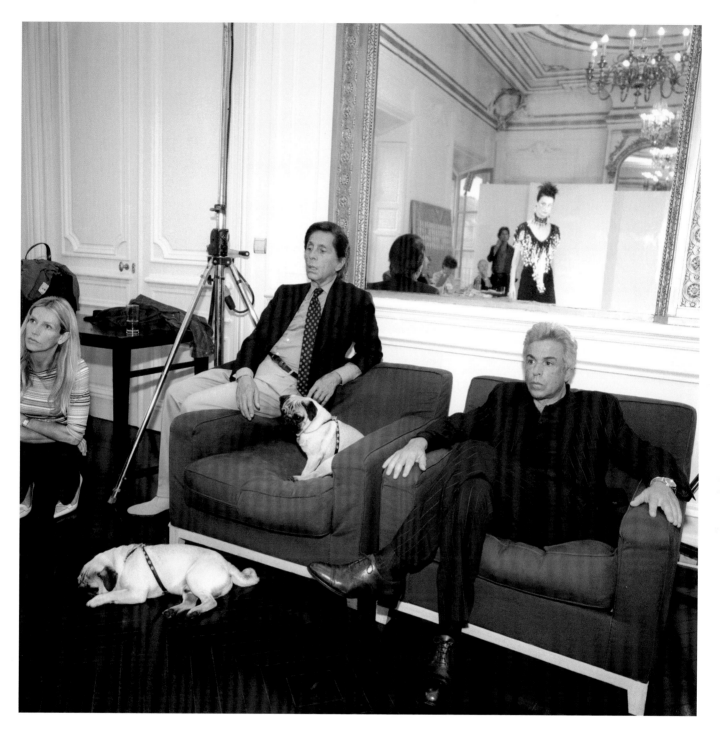

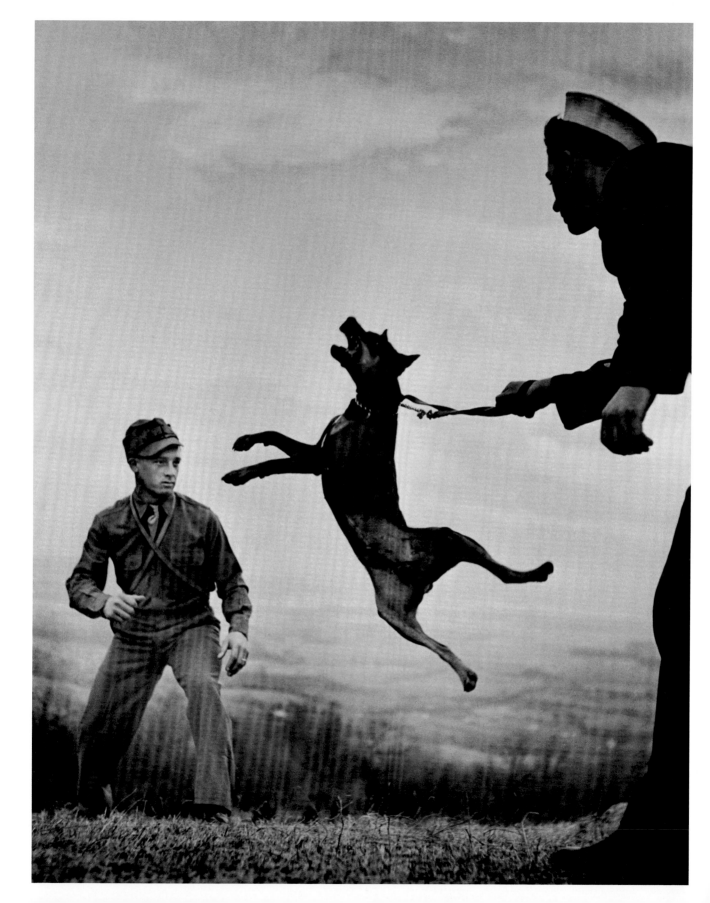

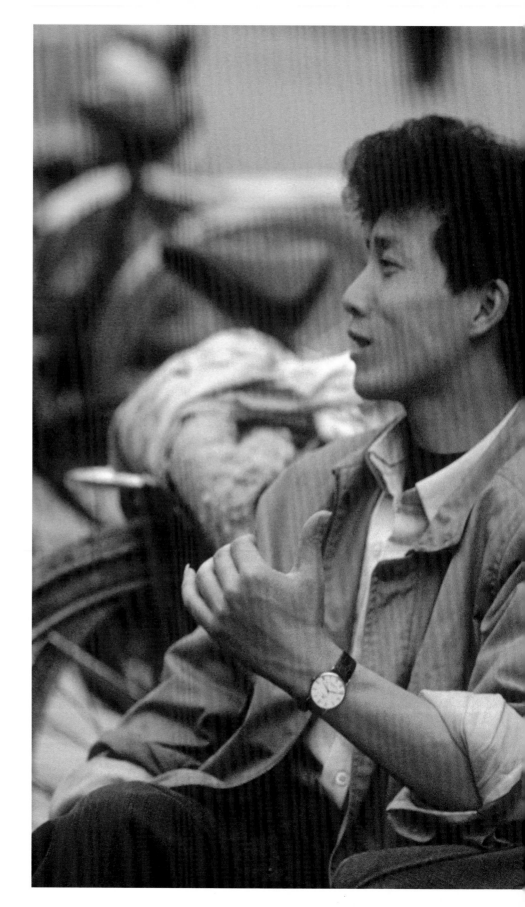

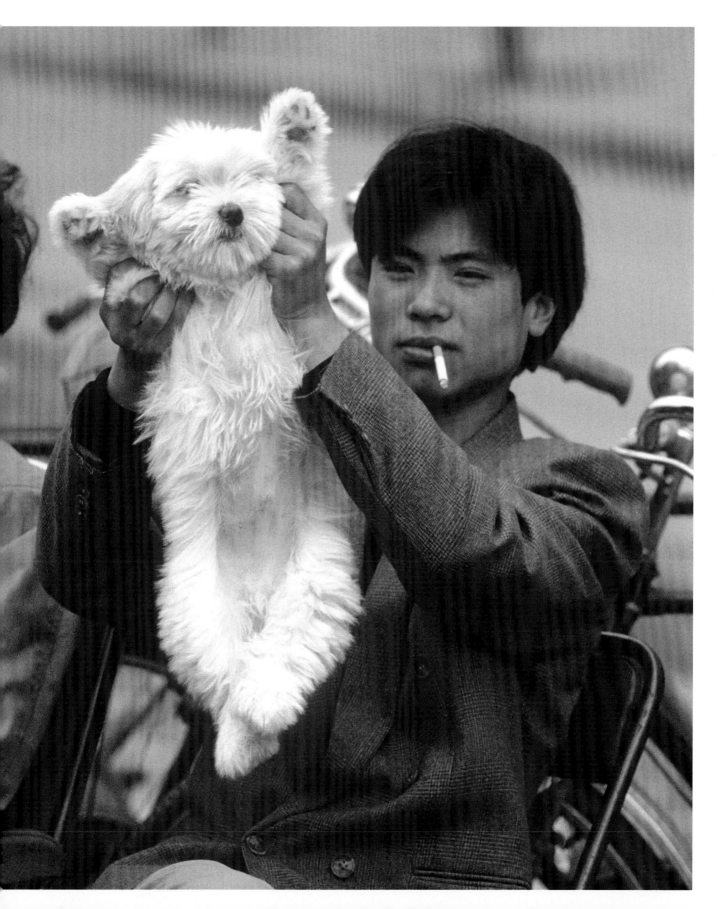

To the Dogs

"Dogs have more love than integrity.
They've been true to us, yes, but they haven't
been true to themselves."

—CLARENCE DAY

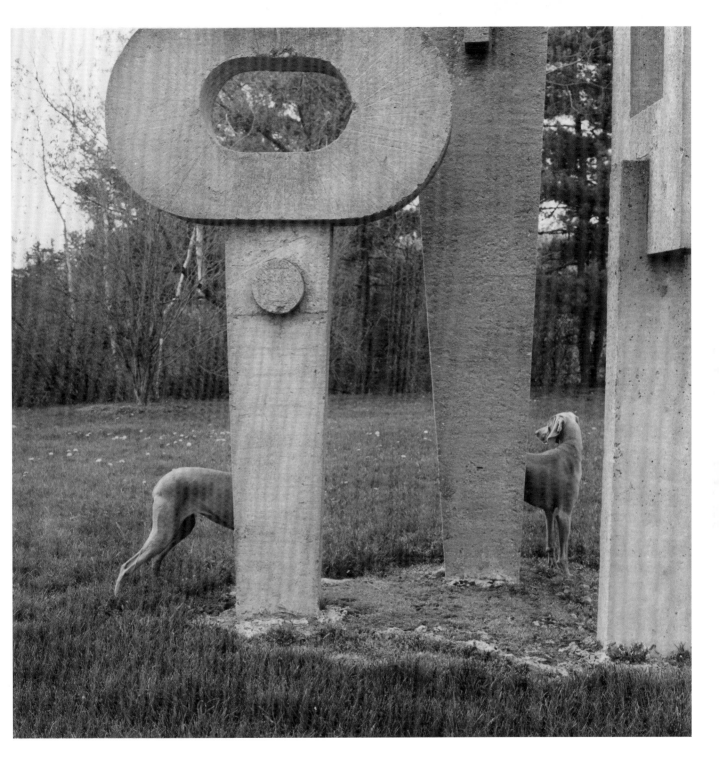

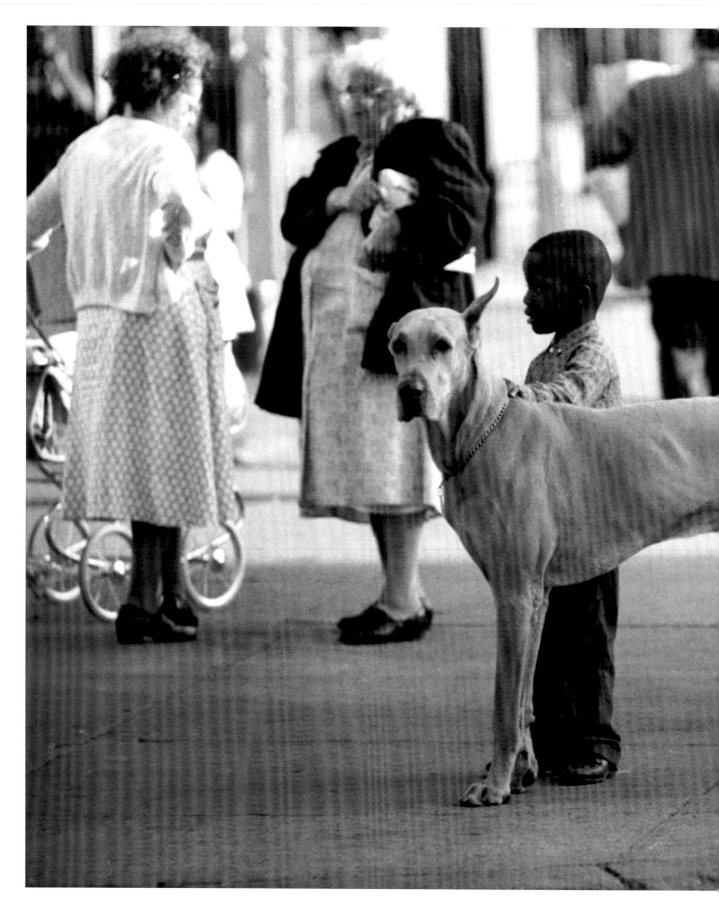

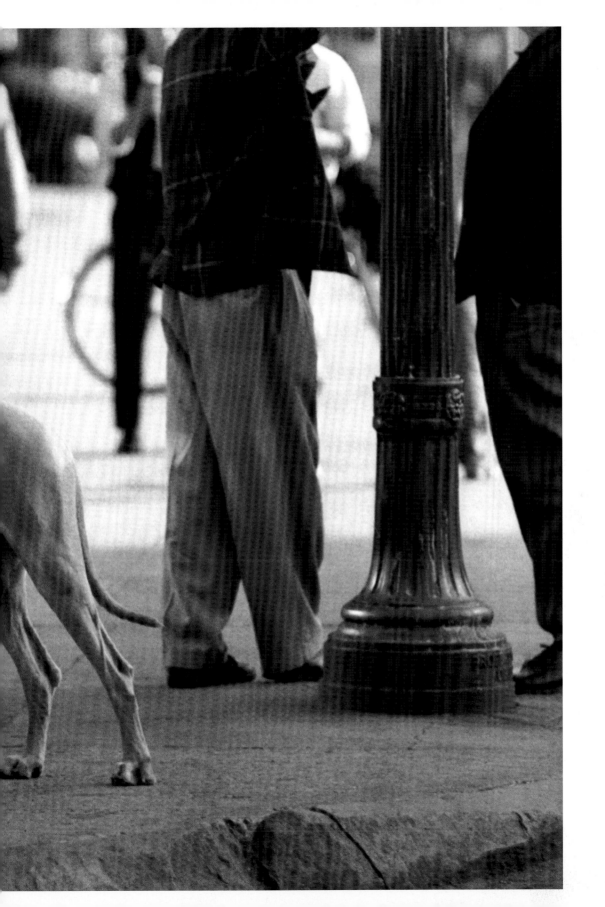

To the Dogs

Text copyright © 2008 by Peter Culley

Published in conjunction with the exhibition *To The Dogs* at Presentation House Gallery, curated by Diane Evans, Helga Pakasaar, Reid Shier and Jordan Strom, June 30 to August 5, 2007

All rights reserved. No part of this book may be reproduced or used in any form by any means—graphic, electronic or mechanical—without the prior written permission of the publisher, except by a reviewer, who may use brief excerpts in a review, or in the case of photocopying in Canada, a license from Access Copyright.

Edited by Reid Shier and Mark Soo
Book design by Derek Barnett, Information-Office.org
Cover photograph by Peter Hujar
Printed and bound in Canada

Presentation House Gallery
333 Chesterfield Avenue, North Vancouver, BC Canada V7M 3G9
presentationhousegall.com

Presentation House Gallery is grateful for the ongoing support of the Canada Council for the Arts, the BC Arts Council, the City of North Vancouver and the District of North Vancouver, the North Vancouver Office of Cultural Affairs, and the BC Gaming Commission.

Arsenal Pulp Press
Suite 200, 341 Water Street, Vancouver, BC Canada V6B 1B8
arsenalpulp.com

Arsenal Pulp Press gratefully acknowledges the support of the Canada Council for the Arts and the BC Arts Council for its publishing program, and the Government of Canada through the Book Publishing Industry Development Program and the Government of British Columbia through the Book Publishing Tax Credit Program for its publishing activities.

Library and Archives Canada Cataloguing in Publication

Culley, Peter, 1958–
 To the dogs / Peter Culley.

Co-published by: Presentation House Gallery.
ISBN 978-1-55152-241-8

 1. Dogs—Pictorial works. 2. Dogs.
I. Presentation House Gallery II. Title.

SF430.C84 2008 636.70022'2 C2008-904097-X

To the Dogs

PRESENTATION HOUSE GALLERY /
ARSENAL PULP PRESS
VANCOUVER

DOGWO

PETER CULLEY

RLD

1. DEFINITIONS

If you were going to get a pet,
what kind of animal would you get?

　　　—Robert Creeley

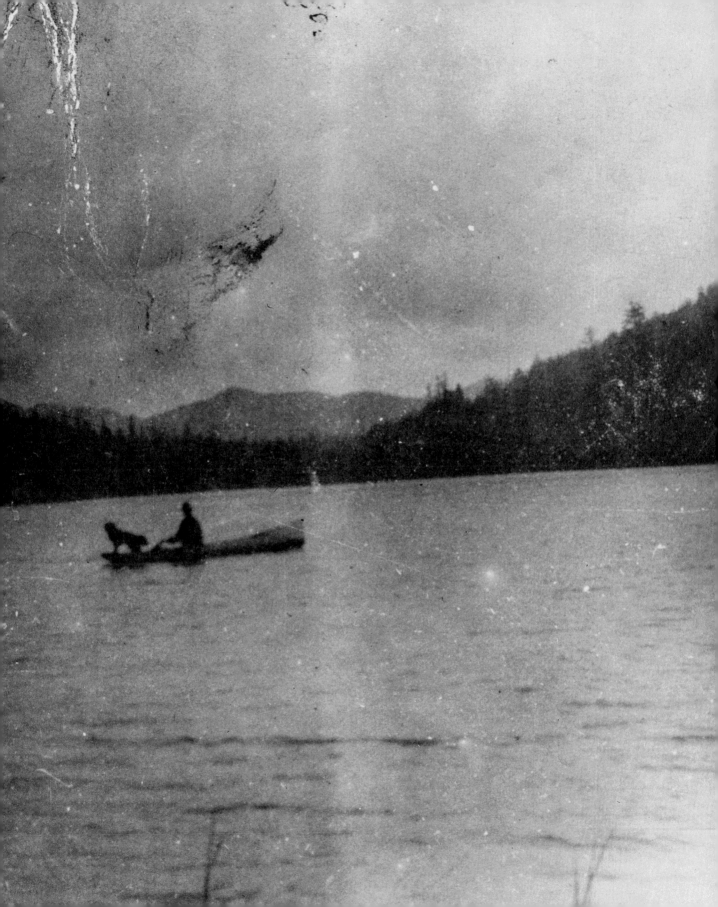

Of dogs my father held a low opinion. We were a cat family. Cats had "dignity." When moving, which as an RCAF family we did every eighteen months or so, cats could be left without conscience "on a farm" or even packed up cageless in the car with us—along with a vast copper thermos of root beer—for the long drive to the new base. They didn't ask for or require special treatment. Mostly dogs lacked dignity, or in my father's words, "Anything a dog can do, you can watch." As I was mindlessly intoning this in a conversation a few years ago (presumably while waiting for an idea of my own to come along), a friend shot back, "Anything a *man* can do you can watch, you mean...." Well, precisely. Weren't dogs, with their tail-wagging, crotch-sniffing and shameless collegiality, a little bit too much like us at our worst? TMI, as the kids say....

I think the gracefulness and droll detachment of cats represented for my father a kind of aspiration, a part of the vision of tough-but-enlightened gentility he carried from the impoverishment of his East London boyhood: a gentility streetwise but knowledgeable, that surveyed the world from a warm, secure and inaccessible spot. Not the life of a roaming cur, driven by whim, subject to weather and misfortune, anybody's buddy for the price of a cookie and a head scratch. Perhaps, too, the dogs' tendency to obsequiousness in human company too forcibly reminded him both of the forelock-tugging class relations he'd left behind in England and the over-easy intimacy of the Canadians he had found himself among.

But his chief objection was—and this is a problem he had in common with almost everyone who has ever had to think or write about dogs—a categorical one: just what exactly *is* a dog, anyway? With a quick Martian glance, it's hard to believe that the Siberian husky and the Chihuahua in Paris Hilton's purse inhabit the same *planet,* let alone the same gene pool. Let's just say their deviations from a common ancestor are not immediately apparent. If on the other hand, behind every cat—from saber-toothed tiger to Hello Kitty—is a pretty, identifiable, abstraction (a few lines drawn in the dirt with a stick would suffice for both), the possibilities of what is or was or might eventually become a "dog" seem limited only by their own fecundity, human ingenuity and time. For my father, this inexhaustible multiplicity of form disqualified them from serious animal status, as if the species as a whole had failed to display the cat's "dignified" loyalty to its standardization. And in a distinction to which we shall return, the cat is *tamed,* the dog *domesticated.*

The variety of dogdom was also tainted by its connection with a human desire often perverse and wayward in its requirements: many breeds of dog (like the pugs that can't breathe properly or the bulldogs who can't reproduce without outside help) give off an air of decadent overachievement, like orchids or certain kinds of formalist poetry. The *Canadian Kennel Club Book of Dogs* is almost 1,000 pages, most of those devoted to photographs, diagrams and highly detailed breed descriptions: that's a lot of waiting around to see how the puppies will turn out, a lot of bitches worn out from too much child-rearing, a lot of broken hearts when the markings don't appear as they should. Eugenic practices discredited among humans with a whiff

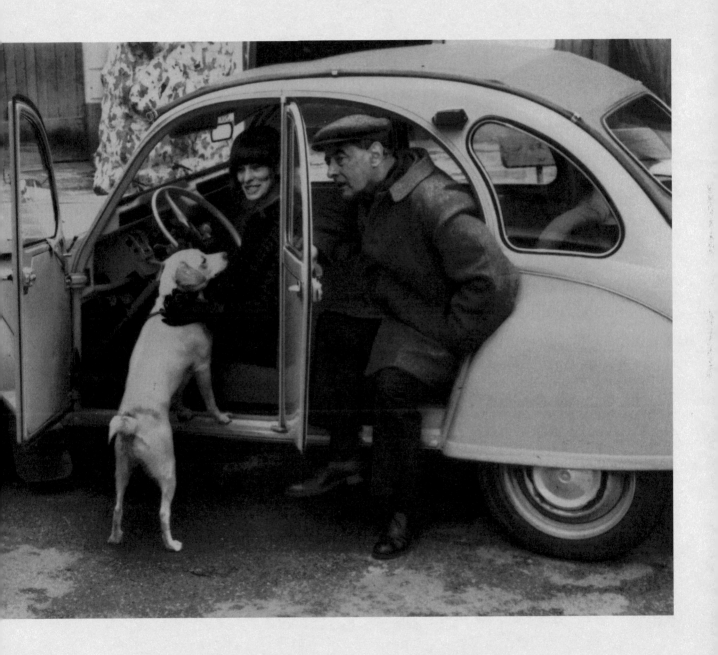

of Nazi horror still thrive in the dog world. But whatever the individual result, every dog is partly the product of human will expressed over countless generations; the qualities of its character and appearance are the result of calculations as recent as the latest trends in ear posture or older than recorded history. The needs of the Paleolithic hunter, the frontier settler, the suburban ball-tosser and the weekend exhibitor must often contend within the same animal.

My father's discomfort with the sheer scale of the dog's potential appearances and habits might too have reflected an Englishman's discomfort with the mere fact of polyglot-ness itself—too many kinds of cheese, too many pages in the menu, too much of a good thing. But his difficulty with the inadequacy and imprecision of the term "dog" is as I have said a general one. The mind naturally hesitates a little before such a capacious construction. Even such fearless pillars of lexical precision as the *Oxford English Dictionary* and the definitive 1911 *Encyclopedia Britannica* tend to sniff the air and scratch the earth at the moment of actual definition: The *Britannica* tentatively dips its toe with:

> the English generic term for the quadruped *Canis*. (Fr. *chien*.) The etymology of the word is unknown.... [I]t is suggested that the "English *dog*—for this was a regular phrase in continental European countries— represented a special breed"

before basically admitting that there is no real and absolute difference between dog and wolf other than that "the eye of the dog of every country and

species has a circular pupil, but the position or form of the pupil is oblique in the wolf."

Little enough distinction, perhaps, but this description is the basis for six grandly systematizing pages of text and four pages of handsome rotogravure grids featuring long-vanished Edwardian show winners. The *OED*—never to be outdone in the functional flatness of its impossible-to-misinterpret definitions—has this characteristically bone-dry bit of bet-hedging:

> A quadruped of the genus *Canis,* of which wild species or forms are found in various parts of the world, and numerous races or breeds, varying greatly in size, shape, and colour, occur in a domesticated or semi-domesticated state in almost all countries.

Again, no very clear "dog" looks up from this, nothing that would enable our Martian to pick one out of a line-up. But over the next eight pages, the *OED*—whose glory is its barrage of sample sentences carefully plucked from across the English language's written corpus—tracks the word through its every shift, derivative and prefix, so that within a few lines we have a citation from Langland's 1396 *Piers Plowman,* "Thi dog dar not bark," which contains a recognizable dog in a familiar situation. A few lines later, from Alexander Pope's 1732 *Essay on Man,* "His faithful dog shall bear him company," and looking up a bit, from Shakespeare's *Twelfth Night,* "If I thought that, Ide beate him like a dogge." Very quickly the vagueness of the general term is brought up against the specific creatures the sentences evoke,

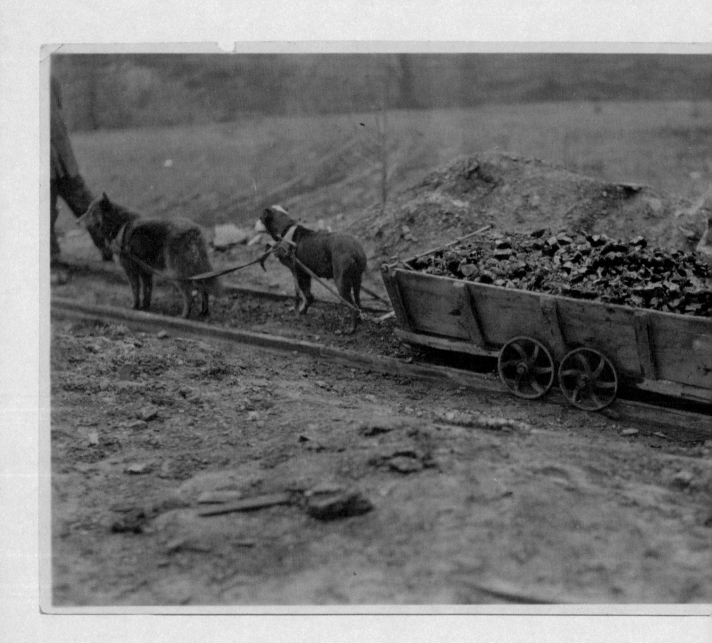

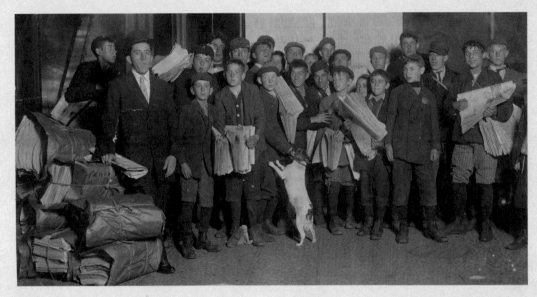

dogs that leap over history to the mind's eye with the same unconscious particularity of the dogs in the photographs featured here.

As we follow the word over the course of its long and branching career, the disparate entries cohere into a mosaic history, a map of the myriad ways in which language, animal and human experience intersect and transform one another. Such ordinary usages as *dog watch*, *dog days* or *dog tired* speak of a ubiquitous presence within human experience, one as familiar and relied upon as the night sky, the weather or the feeling of exhaustion.

Dogs have been with us everywhere all along, from the High Arctic to the Olduvai Gorge, witnessing crucial turning points of human history. From Sparta to Stalingrad to Abu Ghraib the dogs of

hunting, war, cleanup and guard duty have been working hard on our behalf; serving without complaint, observing with alertness but without apparent judgment. It is impossible to imagine either a riot or a pool party without their eager, smiling participation; neither the *coureurs des bois* nor the Conquistadors could have conquered the continent without the aid of canine loyalty and observational intelligence. And who can doubt that it was a dog who first claimed the Pacific for European hegemony, looking up "with wild surmise" before dipping an eager paw, just as it was the stolid Laika who gave her life that we might glimpse the abyss of orbital space from Sputnik 2? Not to mention the forty percent of the world's population for whom it remains a valued menu item. People have been addressing each other as "dog" for so long in so many ways and for so many good and bad reasons

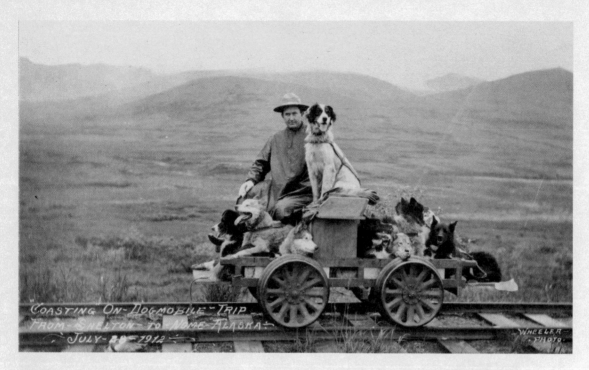

"COASTING ON DOGMOBILE" TRIP FROM SHELTON TO NOME ALASKA JULY 28 1912 — WHEELER PHOTO.

that there seems little in the human condition that the dog condition can't be made to express or comment on. Again my father's distaste for dogs seems a kind of misanthropy inexpressible by other means: it reveals a discomfort with aspects of his own humanity.

The "faithfulness" of the dog is both cliché and description, and it encompasses not only the dogs loyalty to humans but also its equally reliable connection with their older ways of being. The *OED*'s historical mosaic speaks to a connection with dogs that transcends both language and circumstance; in photographs and paintings, the postures and attitudes of the humans can render them barely recognizable in present terms, but the dog is always contemporary.

For those of us who've found ourselves stranded in post-historical circumstances, dogs offer a stability and consistency increasingly rare in contemporary experience: they go on protecting homes as if the bear and the Viking invader were still a factor, go on herding as if the passing mailman were a sheep and greet the homeward returning cubicle drone

with the ceremony appropriate to a bloodstained warrior. The dog's healthy greed and gratitude at the tossed wiener or blackened marshmallow is our infinitely repeatable trip to the hunter-gatherer's fireside. Dogs fetch us the past as readily as sticks. Nostalgia adheres to them like ticks.

The contract between humans and dogs is so ancient that its terms and provisions are lost to us, but no one examining the life of the dog in the West can doubt that we have long been in profound violation of it, that we have presumed far too much on their infinite goodwill. Despite dogs being our frank superiors, if the ability to intuit, relax, smell and defend themselves means anything, we can fool them at will and still do. Enthusiastic but blissfully beyond good and evil, we nevertheless enlist them in our good and evil projects. But while the details of our betrayal offer an endless set of morbid symptoms to be rooted around in, what's more interesting is where our domination falters, where dogs end up revealing aspects of our shared culture while preserving their own integrity; where dogs enter the discourse on their own terms.

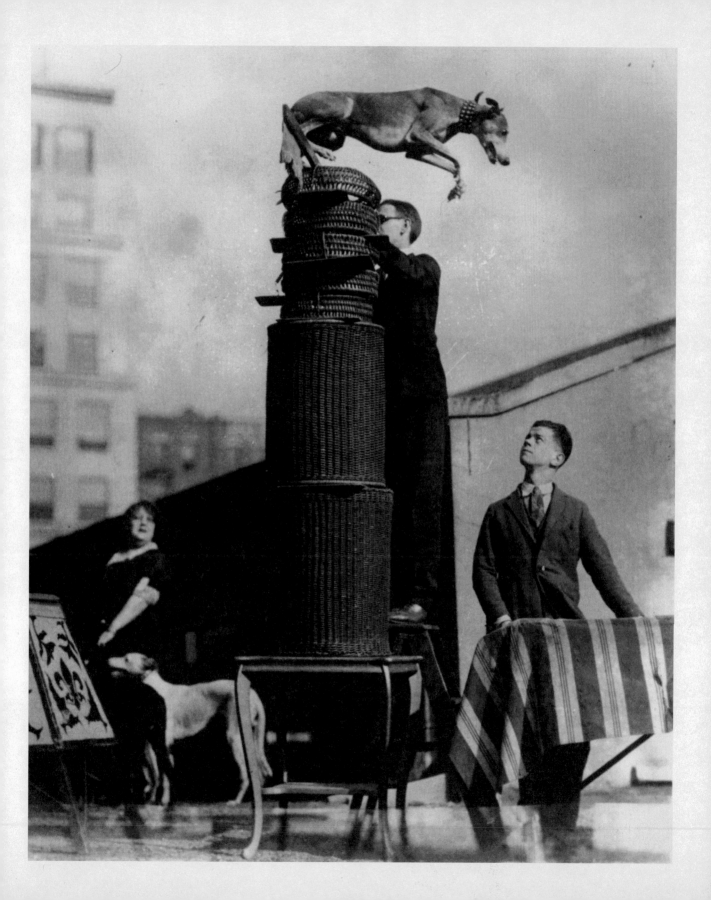

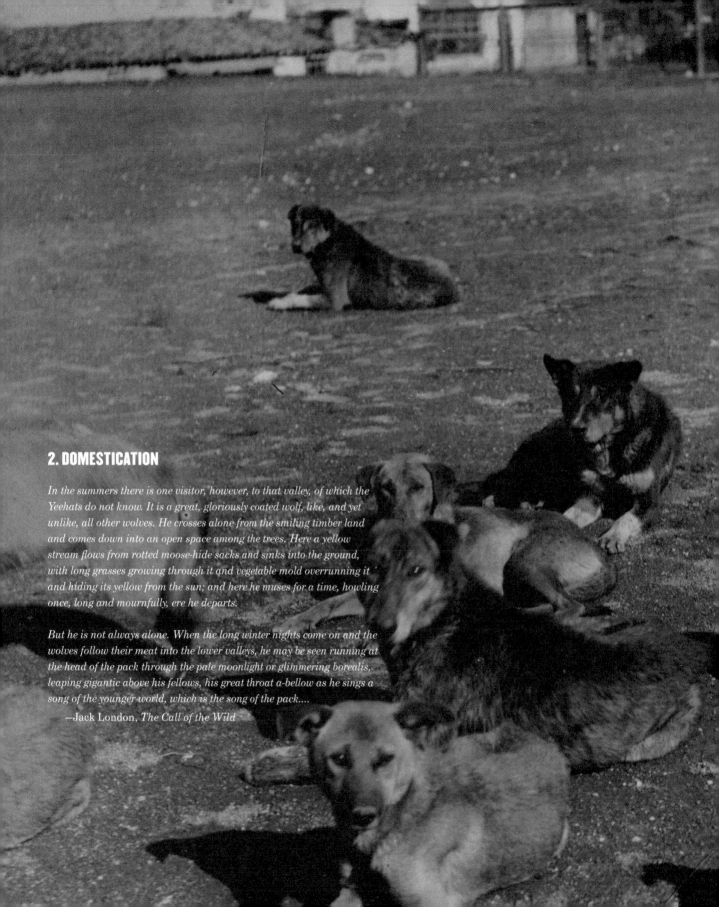

2. DOMESTICATION

*In the summers there is one visitor, however, to that valley, of which the
Yeehats do not know. It is a great, gloriously coated wolf, like, and yet
unlike, all other wolves. He crosses alone from the smiling timber land
and comes down into an open space among the trees. Here a yellow
stream flows from rotted moose-hide sacks and sinks into the ground,
with long grasses growing through it and vegetable mold overrunning it
and hiding its yellow from the sun; and here he muses for a time, howling
once, long and mournfully, ere he departs.*

*But he is not always alone. When the long winter nights come on and the
wolves follow their meat into the lower valleys, he may be seen running at
the head of the pack through the pale moonlight or glimmering borealis,
leaping gigantic above his fellows, his great throat a-bellow as he sings a
song of the younger world, which is the song of the pack....*

 —Jack London, *The Call of the Wild*

Today, very little of the landscape of Nanaimo, British Columbia, where I live, readily reveals itself as ancient Coast Salish territory: generations of mining, logging and aggressively unplanned development have obliterated almost every trace, not only of their congenial civilization but the rapacious resource industrialism that succeeded it. What remains of the coniferous forest is at least third growth; the occasional patches of old deciduous trees the ancestors of plantings that English, Belgian and Orcadian farmers made a century and a half ago. The "hidden" past of the semi-idyllic/semi-rural area where I live is entirely industrial; fast-growing alder groves have filled in everything except for the still-working gravel pit, a few scattered concrete follies, some barrow-like coal tips and some bits of old rail-bed that run for a hundred mossy yards and then stop. All picturesque enough, but the steam engine civilization erased from the landscape all traces of the one it supplanted. To find it, one has to dig. Even the feeling of it is gone, even the ghosts.

Much of the shoreline, though, is still human-scaled—sheltered coves with rain-carved limestone "chairs" arranged under convenient arbutus and Garry oak shade trees, couch-shaped peninsulas draped with wildflower beds and soft forests of succulents—so that a formidably ancient human presence is undeniable. What ghosts there are tend to take the form of unstable weather. But by the casual act of plunging one's foot into an apparently bottomless layer of seashells so broken they've softened into sand, one is reminded not only that humans relaxed barefoot here for millennia but also cultivated shellfish, harvested camas root, and

wove from cedar. Civilization is not solely defined by the extent of its trace. This presence is even more strongly felt on the galaxy of little islands, if you're lucky enough to be able to visit one, that dot the coast like so many aquatic rest stops. Though not designed expressly for human convenience (they lack fresh water), many have such vividly distinct and harmoniously attractive little ecosystems that one leaves them with reluctance. They bring out a person's inner Robinson Crusoe: you start to look for a place to swing your hammock.

It was on some of these little islands that the Coast Salish women protected and tended the "little wooly dog," the only breed indigenous to this part of the world, now extinct. For a little over five decades, these dogs flit through the historical record, then are gone. First noted by George Vancouver at Restoration Point in May of 1792, and described in the same year by a crewman of the Spanish Sutil-Mexicana expedition then anchored off Gabriola Island (near Nanaimo):

The Indians also offered new blankets which we afterward concluded were of dog's hair, partly because when the woven hair was compared with that of those animals there was no apparent difference, and partly from the great number of dogs they keep in those villages, most of them being shorn. These animals are of moderate size, resembling those of English breed, with very thick coats, and usually white: among other things they differ from those of Europe in their manner of barking, which is simply a miserable howl.

The dogs were kept on islands to prevent them from breeding with or being harmed by the bigger, meaner hunting dogs; they were fed and watered by boats dispatched daily, and shorn of their thick, water-resistant coats twice a year. The resulting cloth, often made by interweaving with cedar, was an important source of clothing and blankets, and dog ownership was a measure of social status among Salish women.

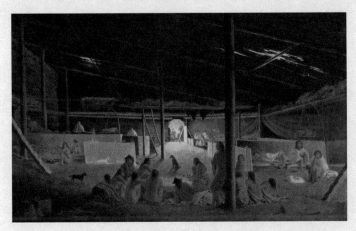

The only visual record of the breed is in the National Gallery of Canada, in Hudson Bay Company painter Paul Kane's c. 1851-56 *Interior of a Clallam Winter Lodge, Vancouver Island*. In it, two of the dogs, about the size of small poodles, attend alertly to the their masters. They are clearly a vital aspect of the painting's cozy and carefully depicted indoor life; truly domestic and beloved, their presence must have livened winter's dullness as well as keeping out the chill. But the same company that brought Kane to depict the Natives brought the Hudson's Bay blanket, which became commonplace, replacing those made by the Salish women; as a result, in the same decade as Kane's painting, the weaving skills began to fade and soon enough, the dog did too. Within the larger genocide, a tiny extinction. Their last appearance in the historical record is taken from the account of Jonathan Miller, Vancouver's first postmaster, who while attending a potlatch in 1862 saw what he thought was one of the breed being devoured. However, such things were known to be faked, and I prefer to think that they were.

I recount the tale of the "little wooly dog" not only as necessary preface to my own anecdotal contribution to local dog history but also as an example of how quickly the processes of evolution can turn against you, the contingency of the most secure niche and adaptation. The discrepancy of scale is astounding: countless generations spent evolving a coat that could repel moisture and a personality that could willingly accept regular shearing, all undone by the introduction of a single product, the Hudson's Bay blanket. In an instant, their cosseted island life was gone, their status as a living luxury item suddenly superfluous. Sad, but the annals of domestication are made up of an uncountable number of such evolutionary advances and retreats.

Beyond the fact of their being descended from wolves attracted to our hunter-gatherer trash heaps, the actual origin of the dog is unknown and unknowable. No clear narrative emerges from the fossil record. But one look at a wolf and another at the vanished breed so cheerfully underfoot in Paul Kane's painting tells us that the existence of the

dog species could never have been simply the result of a human "taming" a wolf (however managed) and hoping for the best. The evolution of the dog must of necessity have been a collaboration, one that has ensured the thriving survival of both species, with strong agency exerted on both sides.

While most of the historical minutiae that record such events are irretrievably lost, it doesn't mean that they all are: Walter Benjamin's conviction that useful data can be generated merely by walking around attentively works as well or better in small towns and the countryside. Power structures don't much bother to disguise their intentions for the benefit of us podunks and hillbillies; what is corruption in the city is small-town business as usual. And anything a man can do, you can watch. It was said that the nineteenth-century journalist William Cobbett (Benjamin's great predecessor), could judge the economic health of a village by eyeballing the state of the fields, the cleanliness of the milkmaids, and the feel of the dirt between his fingers. So when I assert that I have witnessed something of a watershed in dog history—at the very least a massive local advance of the ongoing process of domestication—it is based on three and a half decades of empirical, if not always conscious, research. Never having learned to drive is qualification for little else.

Living away from my parents' home for the first time in the late 1970s, there were parts of town I was required to cross on foot where the process of canine domestication seemed very far from complete, and in my most fearful late-night moments, hardly to have begun. Having, as I said, grown up a cat person in a cat family, my close-up experience of dogs was limited, and the semi-organized dog packs I would encounter in my nocturnal journeys over Old Nanaimo's Nob Hill probably intimidated me more than they should have. They never did bite me; that distinction belongs to a solo Lambert Avenue Peke in broad daylight, who one day zotted out of his yard and onto my ankle with a speed I still shudder to recall. But being followed for a half mile or so by a motley group of mutts, murmuring *sotto voce* at intervals while maintaining a disrespectfully short distance (walking in that dancing little step that cannot quite declare itself as *hurrying* and hence *provocative—they can smell fear, you know!*) was a little humiliating, even alone as I was. And on some of those same nights, just south of town in semi-rural Cedar, similar gangs (which, as Jack London reminds us, most dogs are more than happy to join) had regrettably graduated to the wanton massacre of sheep, with whole herds murdered for sport, untouched but for killing wounds. The next morning, owners would find their prize cockapoos and collies dreaming under the porch, muzzles matted with blood. A little smaller or weaker and my delicate half-trot wouldn't have got me very far. They would have killed me if they could, for kicks, or so I thought anyway; more likely they were just bored, following me along on my route, which couldn't have been nearly as far as I remember it. But it turns out their nights of roaming were numbered anyway.

It is hard to describe just how utterly deserted and dark Nanaimo was in the "wee hours" of those distant nights. Before sodium vapor streetlamps were introduced sometime in the early 1980s—their

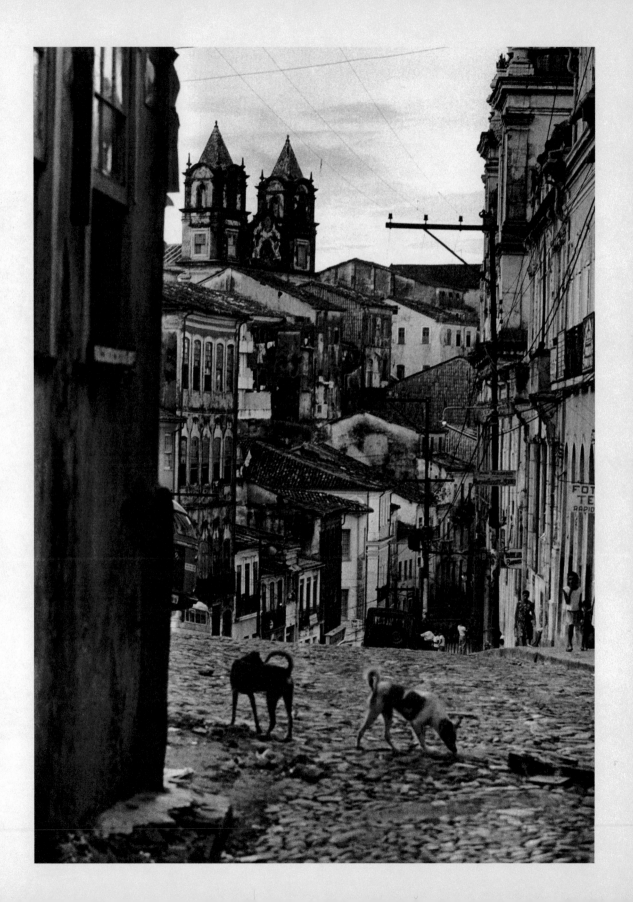

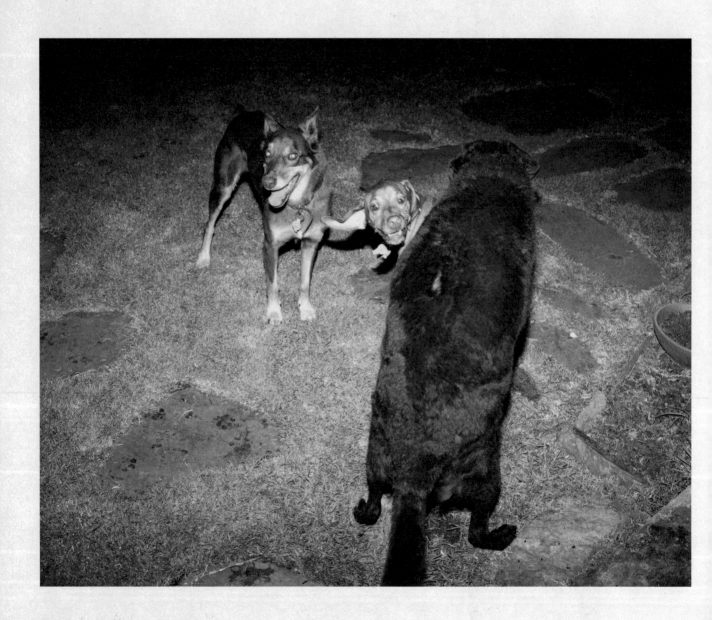

burnt-orange surveilling glow spreading south towards us from the north end's new car dealerships, malls, parking lots, housing developments and industrial parks—nighttime Nanaimo was a dim and mostly uninhabited country. On these late night strolls, a passing car was a rarity, a passing pedestrian almost unknown. After midnight, a dull-blue TV glow might emerge from one house in ten, but otherwise sleep reigned. No motion detectors detected your motion, your passing triggered no lights. No cameras stared, no police passed. Before the twenty-four-hour doughnut shop landed on Terminal Avenue, nothing was even open, so there was no place to spend money, assuming you had any, which you generally didn't. The dogs were the only frightening thing about the wee hours, and mostly because I was a wimp who had strayed into a space and time that were still, for a while at least, theirs.

The owners who put their dogs "out" on these nights had faith not only in the night's essential benignity, but also that they were realistically acceding to their dog's true nature, its reiterated desire to wander around for a bit, howl at the moon, sniff the breeze, perhaps even encounter a stranger of its own species for the pleasures of status establishment combined with a little anonymous sex or violence. Theoretically Rover could then return to his daytime role of companion animal with renewed energy and commitment, having both gotten in touch with his "wild" side and "worked off a little steam." A wink-and-a-nod here. Adolescent boys still enjoy many of the same privileges.

Jack London's definitively "red in tooth and claw" Darwinian novels *The Call of the Wild* and *White Fang* enact this evolutionary catch-and-release over the course of their mirrored narratives, the first where the bon-bon-eating San Franciscan Buck "finds himself" as the man-killing alpha dog of an Alaska sled team and then in *White Fang*'s re-enactment of the primal moment of taming, where an actual wolf eventually hears the equally strong call of the warm fireside. London's fable is partly a eugenic one, where the comforts of polyglot civilization forever threaten to dilute an essential strain of ancient wild purity, and must have been a comfort to those packs of readers, trapped in the narrow beds of industrial civilization, who felt something primordial stir at the sound of a distant siren as they once would have at a distant howl. By selectively drawing on inner resources of "wildness," dog and boy could roam between human and animal realms in a controlled way, enacting a liberatory blurring of civilization and anarchy, consciousness and unconsciousness. And from Mowgli to the Wolf Man, the image of the roaming feral dogchild still exerts a powerful attraction. However crudely essentialist such ideas may have been, however much statistically safer a dog (or boy!) who sleeps indoors is, we can still mourn the loss of the night as a place of mystery and adventure. Civilization has a price. But the sheep killers of Cedar put an end to the age—which must have stretched to the beginnings of human settlement—of nocturnal canine freedom, at least as far as Nanaimo was concerned. Dogs were citizens now, like everybody else.

The rapid emergence of the virtual "mall world" north of Nanaimo was, along with the newly illuminated night and the stricter enforcement of leash

laws, an important passage in the city's belated transition from hardscrabble coal and lumber town to minor communications hub. The air of genteel frontier lawlessness which the city managed to carry well into the 1980s could no longer be sustained. And though this process is still short of completion, the end is in sight—if the boondoggle "conference centre" half-completed downtown (the phantom "private lenders" ran out of money, naturally) does little else, it will admit Nanaimo to the elite level of third-tier travel "destinations." This new Nanaimo will not be defined by its perpetually high unemployment rate, its once sulphurous but now shuttered pulp mill, its embarrassing Bathtub Race, high addiction rates or non-existent civic "culture." Instead, a "waterfront" is uneasily Lego'd onto the old city's docks and foundries, with cruise ships ejecting hapless tourists to be herded and sheared along its walkways. A call centre succeeds the pulp mill as the town's largest non-governmental employer, and when the doors of the biker gang's clubhouse were chained by the RCMP (a couple of months before the pulp mill went into receivership) our vast, hidden drug economy began to diversify in earnest. One paradox of this transformation is that the revitalized service economy that allowed for Nanaimo's "renaissance" depended on increasingly punitive social welfare policies. Life for Nanaimo's poorest has become increasingly marginal and visibly more difficult. Drug activity, prostitution and homelessness now define many parts of the old city. Those activities were always there, and often in greater proportion than now, but at least the people who did them could still afford places to live. The thumbnail history of the past couple of decades is that where once Nanaimo

had stray dogs, it now has stray people. An injured human lying on the grass of a downtown park is more likely to get stepped over or walked around and less likely to get help or sympathy than an injured dog. If the word "stray" implies a carelessness deserving sympathy, "homeless" is always the rendering of a judgment. The process of Nanaimo's modernization began with the roundup of the dogs and ends with the abandonment of its poor. It is possible to fall lower than a dog, but it will probably be through your own doing... the fresh air will do you good.

Over time too, the era of the roving dog gave way to the era of the yard dog. However invisibly, the streets were now *administered*, the state in control. People still put their dogs "out" at night, but into a yard that was generally well secured—the pound only lets you know the first time. Whatever exercise and entertainment the dog would get, it would have to get there, or, if fortunate, during the regulation four-block neighbourhood sniff, shit, stroll and bag. The arrival of something as interesting as a burglar would be like Christmas morning. Anyone who walks is necessarily witness to the abject misery and humiliation of the average "yard dog." Dogs don't continually bark unless they're bored and unhappy, and in the dogs that furiously bark at me as I walk up for the mail each day—snouts poking eagerly through the fence—the emotions of aggression, boredom and earnest dutifulness exist in a self-cancelling loop: their barking gives no relief, but can't end either. Humanity has perhaps worse sins on its record, but the transformation of these clever, noble spirits into neurotic backyard prisoners says nothing good

about us. The statistically insignificant numbers of actual working dogs, admirably fulfilling real functions from digging tots out of rubble to detecting plastique at the airport, seem to mock the designed purposelessness and indirection of the others.

Nanaimo is still primarily a place of yard dogs, but even here the final drama of domestication is beginning to be played out: the symbolic movement from the yard to the house, from the animal to the human. The time-honoured, seigniorial slave/master relationship of pet to owner is regarded by many as the residue of a less enlightened age; the cliché of the visiting Martians question on seeing a human following a dog with a plastic bag *just who's in charge here?* has become an open question, though they might have thought the same watching the Coast Salish women rowing to an island with water and snacks. Another cliché *if you want a friend, get a dog* has moved from being a cynical statement about human loyalty to an active instruction many are happy to follow. Yet another cliché that *over time, owners come to resemble their dogs*—has also come oddly true for our society as a whole. Increasingly clannish, volatile, and with an ever-shorter-attention span, much of our culture exists at a dog level already. The inwardness and emotional solipsism endemic to the post-Diana, post-9/11 West has brought the dog indoors as much as our caring leash laws. A lot of people seem to need what dogs offer, and they seem to need more and more of it. It's easy to see the appeal; in a friendship with a dog one needn't fear criticism, contradiction or an invocation of the wider world. A dog won't call you stupid, or ruin the mood by bringing up the Iraq war. In this calculus, light

cleanup duty seems a fair exchange, a seat at the table a reasonable request. But the residue of this collectively implied rejection of the human is a cultural void, a burdensome misanthropy that does dogs no favour either.

"Dogland" was the name we gave to the part of Nanaimo on the border between the Old City and Harewood, through which the Cat Stream (invisible then in the unclipped alder/blackberry thicket that had grown over the midden from the 1962 Chinatown fire) flowed; bounded by Pine Street, Harewood Road and the unpaved alley at the foot of Machleary: it was probably a couple of acres in extent. The alley, a mostly-unacknowledged-because-rarely-needed uphill short cut, was its centre. If dogs were intending to follow me on a given night, it was this alley (in a dark notch between the old streetlights' weak coronas) from which they could be expected to emerge. And though I passed through untroubled on all but a handful of nights, that sense of moving through the autonomous zone of another species was always there and remains in my memory. In a dark corner of town there remained, however briefly, a free republic, a Camelot for dogs, a zone of autonomy into which one trespassed with respect.

3. DOGWORLD

It is the pastoral idea, that there is a complete copy of the human world
among dogs, as among swains or clowns.
 —William Empson, "The English Dog"

They were celebrities and they were rich, and their lives seemed elegant and charmed. They
inhabited a New York of marble lobbies, potted palms, brass-trimmed elevators, and chandeliers,
a city completely different from the one I lived in. I imagined walking from a gilded carriage,
across a polished floor, and into one of those silent, well-oiled elevators and rising above the
desperate future that lay in front of me. The dogs seemed to live in a world not ruled by the laws
of probability, and I thought that any kind of happiness might be possible there. But of course no
one except the dogs themselves knew what their lives were really like.
 —Kirsten Bakis, *Lives of the Monster Dogs: A Novel*

I am I because my little dog knows me
 —Gertrude Stein, "Identity"

Has your dog ever made you cry?
 —From the *At the End of My Leash* questionnaire

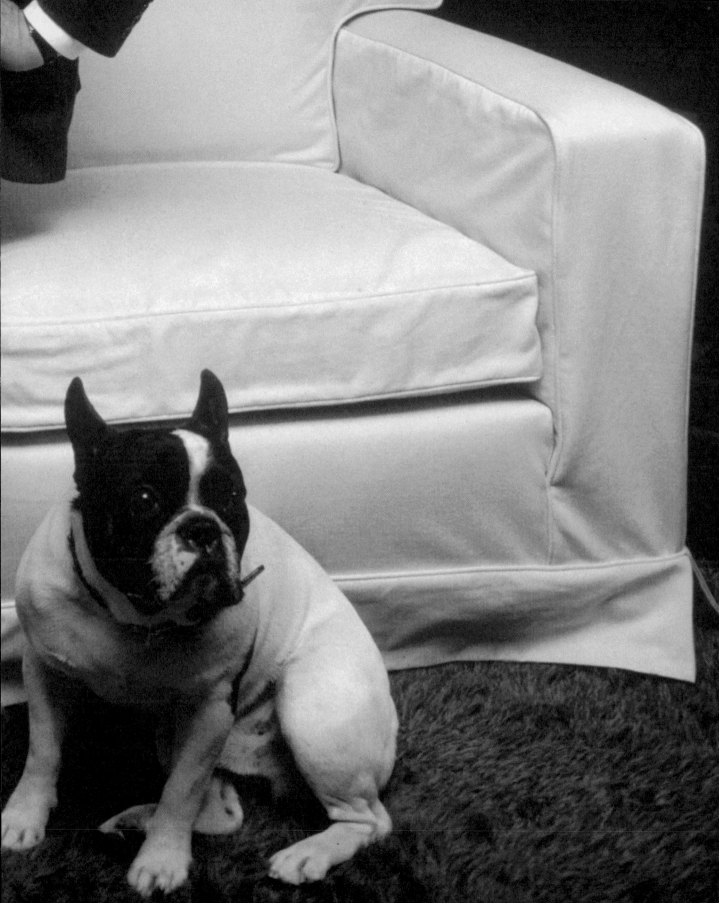

An advantage of living on the periphery is that, theoretically, one can encounter the locally unfolding narratives of globalization with a degree of leisure and mental preparation: events move a little more slowly out here, and there aren't as many of them. Some houses in Nanaimo, for example, are built with blinding haste—between walks to the store!—but often a preparatory pile of fill might see snow, leaves and sprouting dandelions before the foundations are properly laid. Progress is relentless but erratic; it's taken decades for the developers to reach my neighbourhood, and the next "course correction" might yet send them packing. And nearby Vancouver, for all its big-city pretensions, is still a bit of a small town in this way. However much it tries to play off either the flash of its setting or its heavily mortgaged Pacific Rim future Vancouver is still essentially the same old-school open-for-business resource gateway, in some ways as dully Chamber of Commerce Protestant as it was in the corruption- and neon-drenched 1950s. Nothing breaks in Vancouver but waves and weather systems. Two generations of artists have made careers out of documenting the yawning chasm between Vancouver's world-class rhetoric and the tawdry grid of its appearances. The city is a sitting target, and like Nanaimo, one feels that the tide may begin to recede at any minute.

At times, the cleansing "future shock" promised by sociologist Alvin Toffler's 1970 megaselling book (now as forgotten as the jeremiads of Vance Packard, Thorstein Veblen or the *Subliminal Seduction* guy) seemed as much a broken promise of my childhood as jet packs or interplanetary tourism. The profound temporal dislocation I was

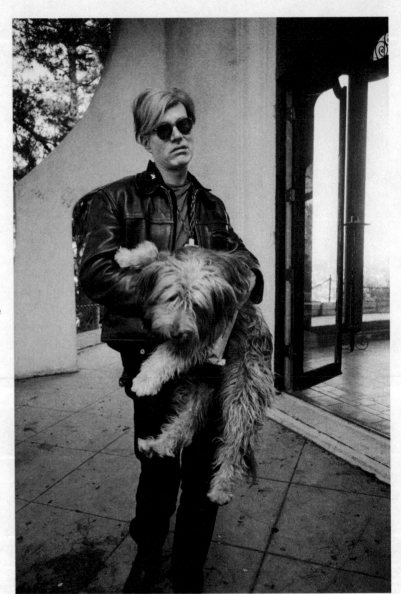

able to momentarily summon after blearily exiting my fourth first-run viewing of *Blade Runner* turns out to have been symptomatic rather than prophetic, the projection of an unearned sense of personal disaster onto misunderstood circumstances. Dumb and dumber. Instead of a war, we had *Apocalypse Now* and *The Deer Hunter*; instead of progress, we had set design with voiceovers, with punk rock the consolation prize. Over time, symptoms (cell phones, Tudor suburbs, techno, laptops, Hummers, Spanish Colonial suburbs, file sharing, Charles Rennie Mackintosh suburbs) continued to pile up—as they must have done in Byzantium—giving an illusion of forward momentum to a profound cultural stasis. It's been mostly busywork since then, and everyone knows it. And then at some point everything receded into "the not too distant past."

But, very much later, long after I'd ceased desiring or expecting it, a true temporal dislocation finally did take place, though by then cleansing wasn't an option. It was on a visit to the island of Manhattan, two springs post-9/11. The shock of the towers' fall had softened the city's hard shell, one result of which was a new and unusual level of simple common courtesy, making it a much gentler place to ask for directions or the location of a pay phone. And in recent years, the *Law & Order* TV franchise has recorded more murders than have actually occurred in New York; the city appears to have avoided the rise in violent crime that has plagued such cities as Baltimore and Houston through the years of the George W. administration. It's as if what New York City had suffered made the gratuitous imposition of trauma a bit less necessary and fashionable. (One of its most endearing qualities

pre-9/11 was the widespread nostalgia for its old and awful days of garbage strikes, bodies on the stoop and 2,000 murders a year; this was replaced by a retrospective fondness for the free-spending, dot-com, "Sex and the City" bubble of the late 90s).

Thus, during a series of very early morning walks through the safe and dappled side streets of Lower Midtown in search of coffee, I began to notice that on some blocks every lone pedestrian other than myself was walking a dog or two. Later in the day—at about the same time that the nannies and minders of the elderly would escort their charges to the parks—the couples and professional multiple dog walkers would appear. But those solo, early morning walkers were companion animals to companion animals, combining a jog or power walk with due diligence for their apartment-bound pets. And it became clear on closer observation that these walks were a little bit more than the grudging two block shit stroll I was used to seeing: dog yanking on lead, owner resentfully stumbling, poised with plastic mitten. These Chelsea morning dogs were different: they must have been trained but it didn't really seem like it—they walked or trotted side-by-side with their owners with a most un-pet-like hauteur, on conditions of perfect equality, their leashes a legal nicety rather than an actual *restraint*. A few chatted amiably with their dogs, though it seemed rude to eavesdrop as well as stare. And if they went to the bathroom, I never saw it.

Many of the dogs were dressed in clothes at least as well-cut and expensive-looking as those of their owners. (On a later winter visit, some of the dogs even seemed to be wearing tensor bandage-like

little snow slippers.) These were not the red-checked bandanas or painful chinstrap Christmas antlers I'd glimpsed in the past, or even the festive little costumes (Sailor Moon/Queen Victoria/Pikachu) that had charmed me at the Ladner Wiener Dog Parade, but quality *clothes,* with the fussy attention to stitching, clasps and Velcro familiar from high-

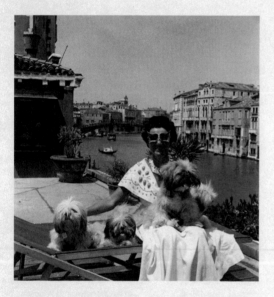

end children's wear. And the new dog stores and grooming palaces I was seeing weren't the kind of places where a dog lover with a business license and a bank loan hooked up a clipper and a cash register, let alone such rural outlets as Nanaimo's Shar-Kare, where barrels of chewable pigs ears and bull pizzles squat next to 50 pound sacks of fertilizer. These shops were *boutiques,* with *design concepts,* about which meetings had been held, sketches submitted, tears shed, vast sums willingly expended.

The more I started looking, the more dogs there seemed to be, intimately bound up in every aspect of New York City life—peeking out from jackets on the subway, riding in carriages alongside babies, leaning on handlebars or long-leggedly keeping pace with joggers along Riverside Park. I had been in a few serious dog towns before, years ago at a diner in Hamburg, Germany, for example—I remember looking down from my steak frites only to be surprised by the melting gaze of an Alsatian beneath the next table, which didn't wander from my meal until the waiter took my plate away. And in Berlin, I saw a magnificent pair of wolfhounds run into a bar—first one, the next about a minute later—and emerge moments later with their master, having presumably fetched him home for lunch. Neither event caused the slightest notice to anyone else present. But however well-trained, the German dogs were still much like the dogs back home or the dogs in the Paul Kane painting—honoured and loved certainly but still *pets,* still at the wrong end of the power scale—for now. The Alsatian knew he wasn't even going to get my gristle and leftover blood-soaked frites; it's why its eyes were so big and sad.

And although the intuition had been percolating for days, the actual moment of dislocating "future shock" only occurred on the morning when I passed an immensely tall, strikingly beautiful woman (she could have been an Irving Penn model) striding down Eighth Avenue, laughing, alternating wet bites of an immense blue cupcake with a bug-eyed pug the size of a can of beer. It was in the fleeting seconds of this joyful, sensuous and entirely unself-conscious exchange that I

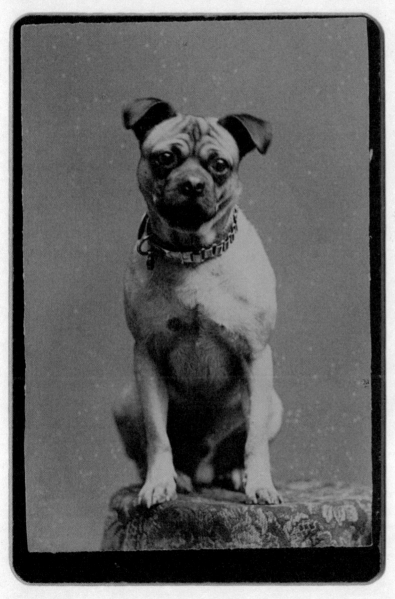

caught a glimpse of a possible posthuman future, one in which, out of deep and mutual need, the barriers between species would begin to fall away. Whatever the cost of its collar the dog was clearly no accessory or Carrie Bradshaw punchline but an entitled equal, a friend, the object of a love neither pathetic nor perverse. And at a point in history when the cost to the planet of our species is a lot easier to discern than the noble legacy of its intellectual achievements, who dares question love between any sentient beings? Where has humanity's much-vaunted uniqueness gotten us lately? For the woman, my momentary glimpse of the posthuman would probably have seemed the belated recognition of an already established fact: in the innermost recesses of her heart, species distinctions must *of necessity* matter less than fealty, reliability and discretion. The way of the world has a way of letting you know who your real friends are, just who's worth sharing your cupcake with. In many of the ways that really count in long-term relationships, dogs enjoy a positive advantage. That expression didn't come out of nowhere....

The emergence of Dogworld in the streets of midtown Manhattan was at first a little hard to distinguish from the concurrent rise of Babyworld. The overdetermined dog boutiques and kiddy couturiers seemed almost identical, especially if— dogless and childless—one hesitated to breach their implied "velvet rope." The same combination of private and civic trauma that had caused so many to welcome the dog so enthusiastically into their lives also had its part in the concurrent baby boom, especially among professional couples in their late thirties and forties. Baby/puppy combos were not

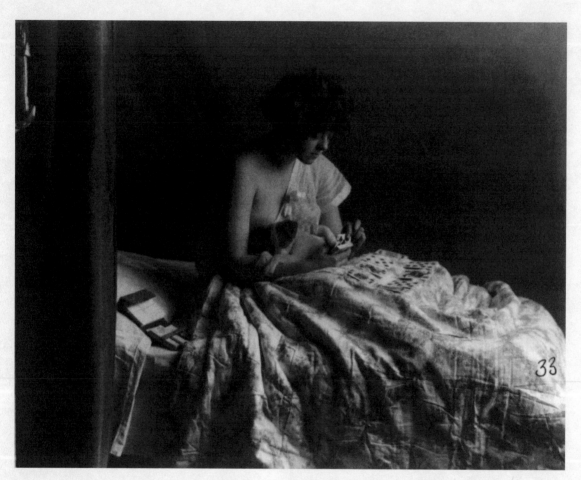

unknown, which didn't help—they often rode side by side in those adorable "twin" carriages—dogs generally riding "shotgun." The commercial aspect of this was clear enough: the consumer who spends one hundred dollars for a dog collar is the sort of person who will spend *a lot* for a baby carriage when the time comes. Mailing lists were undoubtedly traded back and forth. Dogs and childhood have of course always been inextricably linked, for both in physique and temperament, the dog is essentially a juvenile wolf. The process of neoteny, by which childhood characteristics are retained into adulthood, is the dog's evolutionary trump card. The soft fur, big eyes and "clingy"

behaviour of the puppy are identical to that of the wolf cub, it's just that wolf cubs grow up and turn into great big nasty wolves. By staying young, the dog stays in the household. For a pet dog to engage in markedly "adult" behaviour—running in packs, fighting, biting, or reproducing willy-nilly—is to court banishment or death.

In recent decades too, with more and more couples delaying children, the dog often acts as de facto "rehearsal child" (or, piquantly, "Love Dog"), presumably helping to train potential parents in the twin arts of nurturing and discipline. The dog's life-long, ever-renewable state of childhood easily becomes a site where any number of parenting methods (from Dr. Spock indulgence to Dr. Phil hectoring) can be tried out, with little fear of censure, though at times with dire consequences—especially for the dogs. Poet Philip Larkin's line "They fuck you up, your mum and dad" is doubly true for dogs and their owners: if, out of fear of censure, bad human parents have in recent years tended to take their act behind closed doors, visibly deficient dog owners seem unembarrassed, entitled in a way that it's become tougher for human parents to get away with. The casual verbal abuse of children one used to encounter in public fairly frequently is now rare, replaced by impatient deal-making and mollification, but however conversational the average owner is with its dog the tones of authority are never very far away; it's still OK to call a dog an "idiot" to its face, even if it has to involve a comic show of exasperation.

With so many of the trappings of childhood, but so little of its evolving power, it's no wonder so many dogs seem trapped in the "terrible twos." For a creature so conscious of status, the fluid and capricious allegiances of primate society must often seem devoid of sense or logic. The introduction of a child into the household must be a rough transition, however managed: one day you're the baby, being fed cupcakes by hand with honeyed tones, the next day you're the *dog*, daycared out to some no-nonsense professional walker, tied up with a bunch of strangers. The type of nightmare domestic scenario that can result from confusions of species, status and responsibility—the often grim private face of Dogworld—can best be illustrated by an examination of the Canadian television program *At the End of My Leash*.

In the now vast panoply of reality television, *At the End of My Leash* is one of the subset of pet intervention shows (led by Oprah's *Dog Whisperer*, Cesar Millan) which are themselves a subset of the "nanny" genre, in which costumed English Mary Poppins types are introduced into dysfunctional North American families for a bit of (invariably successful) crisis management. All are more or less derived from the "tough love" psychological school of Dr. Phil, in which the re-establishment of parental authority is the instant solution for most domestic problems. Though *Leash* is produced, like most of the detritus of reality and "entertainment" programs clogging our cable networks, seemingly less to be *watched* than to fill the spaces between commercials, its mix of preachiness and cynicism gives it a uniquely Canadian flavour. So too does the host, "Life Coach and Innovative Dog Trainer" Brad Pattison, who eschews both the campiness of the nannies (whose dramatic "reactions" to

the latest toddler horrorshow are pure music hall mugging) and the exasperated but mellow slow burn condescension of Dr. Phil.

Pattison's particular brand of entitled earnestness is familiar to any of us who have been on the wrong end of "soft" power lately: that of the caring functionary, the believer in a cause so ultimately virtuous that, *even in his dealings with the likes of you,* he is prepared to be fair and above board. It's more than you deserve. And like almost everyone placed in a situation of random authority since 9/11, he is a little bit of a cop. But any pretense of *Leash*'s devotion to the actual cause of dog discipline (presumably the source of his authority) is undermined by the show's transparently cynical modus operandi: its screening program begins with a questionnaire (available on the website) as devoted to the rooting out of pathology as the one that Warren Beatty fills out for the Parallax Corporation (in Alan J. Pakula's 1974 conspiracy classic *The Parallax View*), asking such transparently leading questions as: *Is your dog ruining your relationship? How serious is the conflict caused by your dog? What impact has your dog had on your relationship? Has your dog ever been nearly killed (by a car, etc.) because of misbehaviour? Have you ever discussed giving your dog away to eliminate the arguments?*

Which leads to another set of questions, beginning with: just what sort of person would fill out such a form? As with the nanny shows, the default position of the parents/owners is always assumed to be one of utter desperation and hopelessness. The entire premise of such a program depends on the fact that anyone answering such a questionnaire is *ipso facto* prepared to cede authority to the show's master narrative, no matter how humiliating or deceitful. "Expert" and crew insert themselves into the lives of their subjects with no regard for their privacy or dignity. The worse things go, the better television it makes. The redneck free-for-alls of Jerry Springer come to seem models of informed agency. And while the likes of Dr. Phil and Cesar Millan are able to soften the cruelty of their exploitation with the application of a little Oprah-esque goo, *Leash*'s lower budget and smaller talent pool highlight both the discomfort and dysfunctionality of its subjects.

Pattison's "technique," part intervention, part counseling session and part heavy-handed cult deprogramming, seems aimed at breaking down the nexus of dysfunction by destroying and then building back up a family structure corrupted by an unhealthy and destructive refusal to assert "natural" human primacy. Unless you mark the boundaries with a firm and steady hand, the family unit becomes a *pack,* your house becomes a *den*. Pattison has an easier time concealing his distaste for the ill-trained and unhappy pets than their hapless masters, but in either case the goal seems to be to humiliate and badger his subjects into a semblance of domestic order.

Which leads to another question: just whom is this program intended for? Much of the reality genre seems aimed at a truly lowest common denominator: those for whom carefully constructed onscreen dysfunction would act as palliative for the misery of their own lives. But this is less depressing to

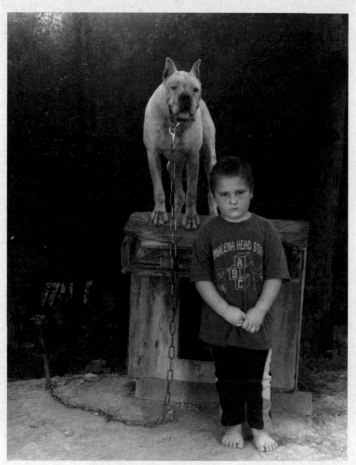

but this is undone by the ludicrous unrepresentativeness of his volunteer subjects and the lurid theatricality of the presentation. *Leash* bears the same resemblance to the actual Dogworld that *Survivor* does to tourism. In an era in which some of the best TV programs have gently tested the boundaries of genre, reality television has powerfully re-asserted the most conservative and complicit of dramatic tropes. From *Survivor* and *American Idol* to the smallest Canadian home-reno show, reality programs are ultimately about the re-establishment of authority, the rendering of judgment from on high. Every program ends with its "reveal," its moment of truth, when the people behind the camera or the desk tell you if your singing or dancing was any good, whether your house passed muster, whether or not you get to stay on the island. Though dogs form only a small part of its subject matter, reality television is one big obedience school.

But however cynically deficient in its depiction of Dogworld, *At the End of My Leash* still has much to teach us about its dark side. The assumption of the show—especially as revealed in its questionnaire— is that not only are there dog owners with problems, but that these problems are so widespread and intractable that a pool of volunteers willing to give themselves over to dubiously motivated strangers could be easily drawn from among them. Judging by the legion of counselors and lawyers specializing in the strains and stresses of dog-human interaction, no one ever went broke underestimating the amount of pain and grief that arises out of dog ownership, or the extent to which people will go to try to make it stop.

contemplate than that there are those for whom the unvarnished depiction of manipulative bullying is "entertaining" in some kind of post-ironic way. The unspoken premise that gives energy to Pattison's assumption of authority is that somehow this kind of program transcends mere morbid curiosity by offering *practical guides for conduct,*

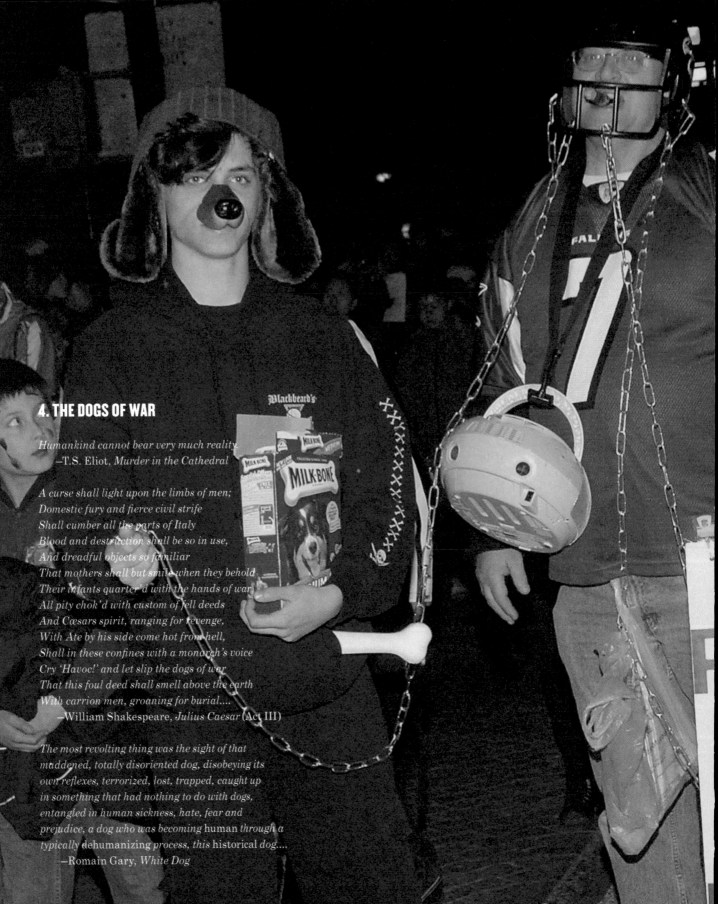

4. THE DOGS OF WAR

Humankind cannot bear very much reality.
 —T.S. Eliot, *Murder in the Cathedral*

A curse shall light upon the limbs of men;
Domestic fury and fierce civil strife
Shall cumber all the parts of Italy
Blood and destruction shall be so in use,
And dreadful objects so familiar
That mothers shall but smile when they behold
Their infants quarter'd with the hands of war;
All pity chok'd with custom of fell deeds
And Cæsars spirit, ranging for revenge,
With Ate by his side come hot from hell,
Shall in these confines with a monarch's voice
Cry 'Havoc!' and let slip the dogs of war
That this foul deed shall smell above the earth
With carrion men, groaning for burial....
 —William Shakespeare, *Julius Caesar* (Act III)

The most revolting thing was the sight of that
maddened, totally disoriented dog, disobeying its
own reflexes, terrorized, lost, trapped, caught up
in something that had nothing to do with dogs,
entangled in human sickness, hate, fear and
prejudice, a dog who was becoming human *through a*
typically dehumanizing *process, this* historical *dog....*
 —Romain Gary, *White Dog*

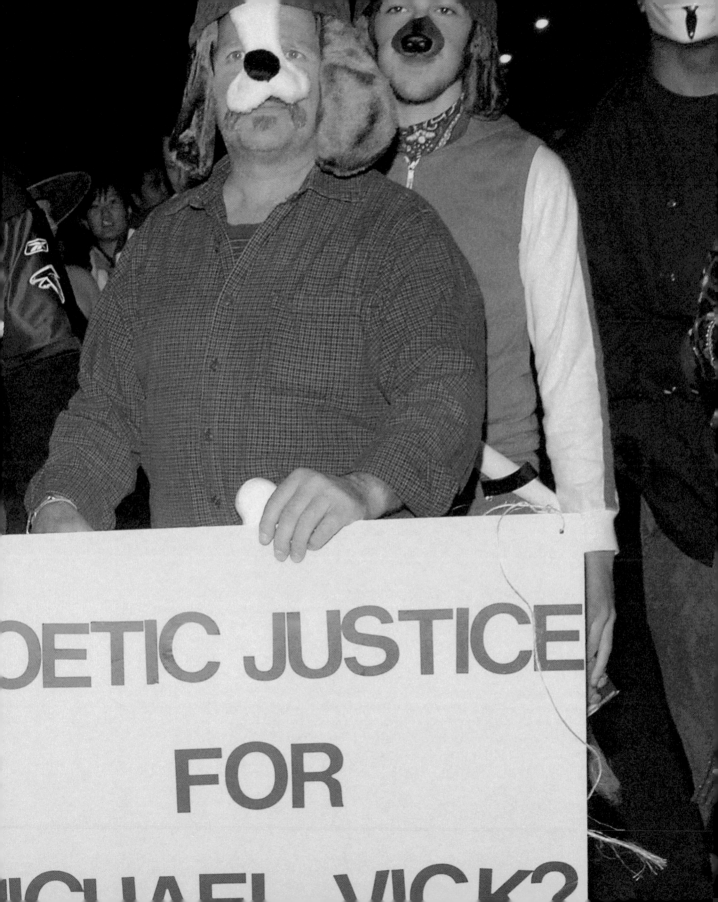

The anger directed towards Michael Vick—the NFL Atlanta Falcons quarterback arrested and convicted in 2007 for his part in the operation of an extensive dogfighting ring involving seventy pit bulls—was certainly understandable. There is no diminishing or justifying either the "sport"'s shameful cruelty or Vick's long-term, enthusiastic participation in it. As early as 2001, Vick's father told a reporter, "This is Mike's thing, and he knows it." But the white-hot intensity of the reaction was unusual. Was it simply collective relief in finding that here, at last—amidst the free-floating "rage" at everything from gas prices to Britney's parenting— was something worth condemning with a whole heart? Without ambiguity or guilt? As in the run up to the Gulf War, a lot of people got a little high on the fumes of their self-righteous fury: a cursory examination—which I don't recommend and won't quote—of the world of sports blogs and chatrooms found any number of dog lovers and disappointed fans eagerly indulging fantasies of torture and retribution. Even given the Internet's capacity for the amplification of hysteria, the reaction seemed oddly overscaled.

A number of reasons suggest themselves in addition to the gravity and distastefulness of his crimes. In a culture that tends to forgive almost any crime if accompanied by sufficient contrition and a consistent excuse, Vick offered neither. Even before his arrest, Vick was the model of the contemporary professional athlete: consummately skilled (in 2006, he became the only quarterback in NFL history to rush for over 1,000 yards in a single season), grossly paid (Vick's ten-year contract, signed in 2004, was for $130 million, with a $37 million signing bonus), entitled, arrogantnobody's "role model." Race had its inevitable part to play. But at least part of the reason that so many felt empowered to strenuously condemn him was because the Vick case brought to urgent attention a number of issues that a lot of people would rather not have to think about. Woe betide those who would remind us too forcefully of our collective failings and hypocrisies. That there are at least 40,000 Americans professionally engaged in the breeding, buying and selling of fighting dogs was a fact that official Dogworld was happy to consign to oblivion: in fact, there were so many for whom the Vick case seemed their sole introduction to organized dogfighting that it was as if he were to blame for the activity's very existence.

For most of his life, Vick occupied without impediment the center of a vast continuum linking sports team owners and dog breeders; drug dealers, talent scouts and gamblers; lawyers, "handlers" and police. His on-field skills brought him a lot of money and even more slack. And like Vancouver's convicted serial killer Robert "Willie" Pickton, whose murderous spree attracted little notice from authorities until very late in the game, Vick was probably only vaguely aware that what he was doing was a crime. Like Pickton (or the guards at Abu Ghraib), there was nothing or no one around to stop or even censure him. Pickton didn't become a sought-after "serial killer" until the political climate around Vancouver's impoverished Downtown Eastside changed enough to grant his female victims (most of whom were prostitutes or drug users) even that grim, small statistical status. Nothing in the social or judicial climate before

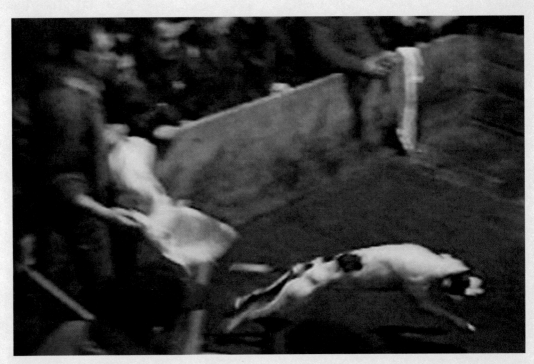

then had suggested to Pickton anything other than the women wouldn't be missed. Certainly not the police, who'd known of him for years. How was he to know the rules had changed?

Vick—whose "Bad Newz" stable of fighting dogs was named after the Newport News, Virginia ghetto where he came of age—grew up in a culture in which dogfighting had been a tolerated activity since at least 1817, when the first Staffordshire Terriers were brought over for that purpose from England, and has only been illegal since 1976. The American South was, in 1817 and for a long time after, very importantly a *fighting* culture, from the dueling aristocracy on down to the feuding poor whites. Violence was how things were settled, period. A slave economy leaves many of its young masters, rich and poor alike, with a lot of time on their hands, time to read too much Sir Walter Scott and entertain thoughts of chivalry and derring-do. Sporting men were known to grow a thumbnail extra long for the purposes of eye-gouging. In 1856, Preston Brooks, a South Carolina senator, feeling insulted by his abolitionist colleague Charles Sumner, walked across the floor of the chamber and beat him half to death with a metal-topped cane commonly used to discipline dogs, and became a hero overnight.

The so-called "thug" culture of the ghetto, with its elaborate codes of honour, respect and retribution, is the living legacy of these slaveholders. And as hip-hop has become more southern in the past decade, images of dogfighting—as in the video for Jay Z's "99 Problems"—have begun to appear more frequently. So it was in the 1980s, when dogfighting became an increasingly black-identified subcultural phenomenon in the South, that (surprise!) law enforcement began to take an interest.

As a child whose gridiron talents became apparent very early on, Vick would have been an honoured lifelong member of a culture in which the ferocity of fighting dogs reflected distinction on their owners, where the "heart" and "game" of a fighting dog was an admired standard of toughness. Bred from long, well-documented championship lines, the dogs too would have shown every enthusiasm for the pit. For reasons quite beyond $40,000 bets won or lost, a condition of mutual admiration, even love, must have existed between Vick and his stable of warriors. As despicable as the gruesome executions of the losing dogs were, their deaths seem more about disappointment and thwarted passion than indifference, more about gladiatorial pride than cruelty.

Present too in this vexed, inevitably exploitative relationship is a shadow version of the relationship between professional athlete and team owner, that tie-wearing white millionaire whose self-esteem somehow depends on the successfully controlled violence of his employees. The vast sums paid to people like Vick tend to emphasize rather than disguise the seigniorial, essentially medieval

nature of professional sports, where "players" run out in their colourful numbered uniforms to do ritualized violence to one another in the name of a corporation. Its role in our culture as a method of social control hardly needs restating here. Fussed over endlessly, wealthy but never as wealthy as his owner, loved in victory but scorned in defeat, possessed by everyone, the contemporary athlete is pet-like in his combination of vulnerability and wildness, violence and subjugation. One thing you can be sure Vick knew with dead certainty: if at any point in his career he had been injured past the point of repair, his fate would have been as swift and certain as that of his losing dogs. No amount of get-well cards or gift baskets from the franchise owner would have saved him. Crippled football players are not executed, but the fate of most ex-players is a litany of pain, permanent injury and corporate indifference. The veterans of our amusements often occupy the same oblivion as those of our wars. Meanwhile, on the sports websites, those few not wanting to boil Vick in oil were trying to figure out just when he would get out of jail and start throwing for the Falcons again. The point spread rests for no one.

Nor do the demands of the entertainment industry: as I write this, the National Geographic Channel is about to start airing episodes of *Dogtown,* a show that will apparently depict the recovery and re-socialization of some of Vick's fighting dogs. Usually, in contrast to the fairly short prison terms handed out to the likes of Vick, the fate of the animals "seized" was capital punishment, no negotiation. Few trainers have the time or the inclination to attempt the "reform" of creatures so helplessly

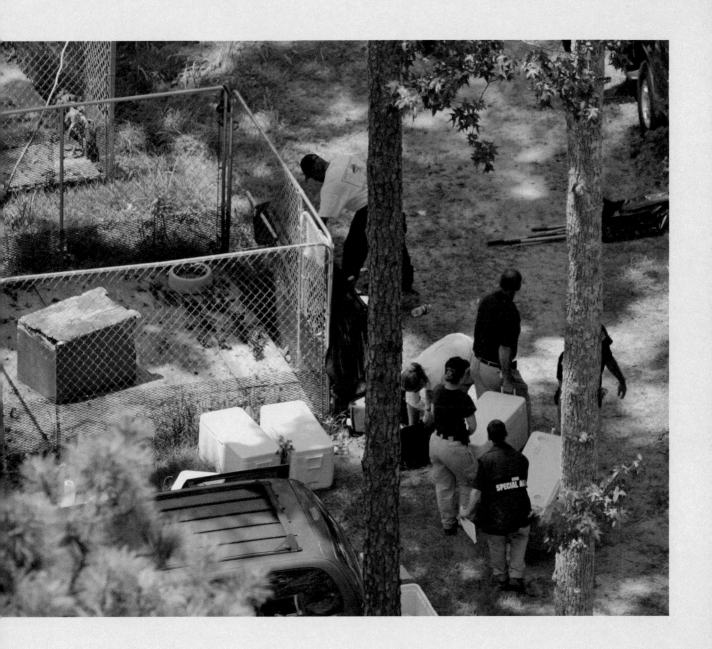

hard-wired. In Romain Gary's heartbreaking memoir *White Dog* (later adapted for film by director Sam Fuller), set against the turmoil of America in 1968 and the dissolution of his marriage to actress Jean Seberg, Gary attempts to retrain a dog that had been taught to attack black people on sight. But the cause is hopeless: the methods necessary to reprogram the dog only compound the horror of its original indoctrination. For the sake of Vick's dogs (if not the program's producers), we can only hope that the intervening four decades have produced more effective therapies. One might hope too that the concept of rehabilitation, which underpins so much contemporary infotainment, might be re-introduced to human penology at some point. For except in places where it really might matter, our culture is drowning in contrition. From the same entertainment pages announcing *Dogtown* is a full-page ad featuring the return of *Dog the Bounty Hunter,* whose wildly popular television show was temporarily cancelled when his son released a taped phone conversation peppered with Dog's free and enthusiastic use of the "n"-word. In the ad, he gazes into the camera, eyes soulfully narrowed, a perfect hybrid of human, shar-pei and golden retriever, an animal born to fetch. He stands on a desert road beside a "crossroads" sign. Over him, the text reads: "I believe everyone deserves a second chance. Do you?" It's not impossible to imagine a chastened, post-prison Vick being put into a similar pose, especially if his skills survive incarceration. How could we refuse his second chance?

For in projecting his social and workplace anxieties into the fighting pit, Vick turns out to be a citizen of Dogworld after all, just another owner unloading because he can. Innocent of everything except a coldly manufactured urge to fight, Vick's dogs were simply presumed upon too much. Like the tail dockers, the puppy mill breeders, the fetishistic groomers and a million others, he had come to depend on the dogs' goodwill in a way that was unseemly and mutually demeaning. Dogs, with their infinite capacity to return our worst instincts back to us in the form of love, represent a terrible temptation. They give us an inch and we take a mile. Our primate inability to leave well enough alone and just relax—a skill at which even the humblest dog has much to teach us—has been a very mixed blessing for the animal that, above all others, has thrown in its lot with us. Like children, their innocence is both a beacon of hope—however dimly perceived—and a constant reproach to our failures of sympathy and imagination.

Peter Culley was born in 1958 and has lived in Nanaimo, BC since 1972. He has published six books of poetry including *Twenty-one, Fruit Dots, Natural History, The Climax Forest, Hammertown,* and the newly released The *Age of Briggs & Stratton* (New Star, 2008). His critical writings on visual art have appeared in numerous magazines and catalogues, including major monographic essays on the work of Roy Arden, Stan Douglas and Geoffrey Farmer.

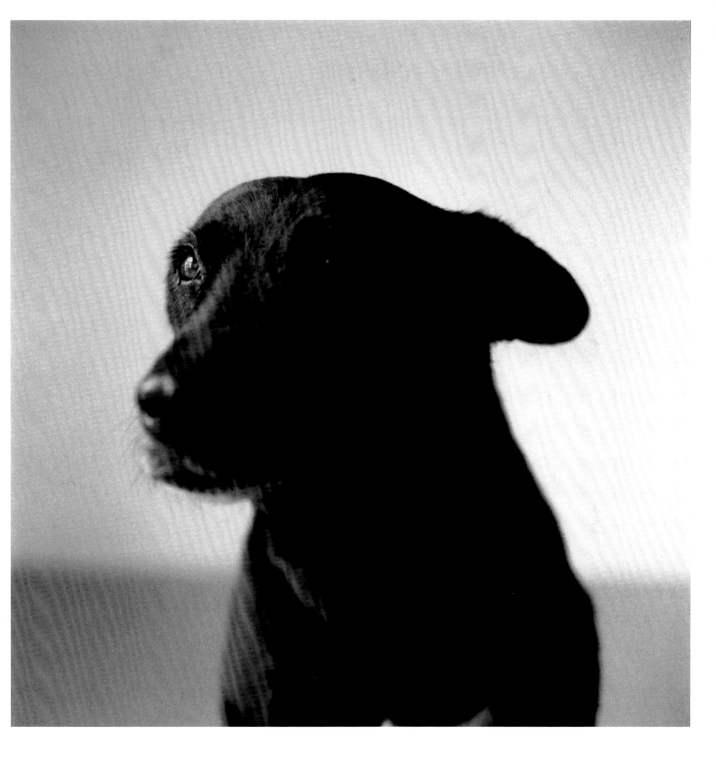

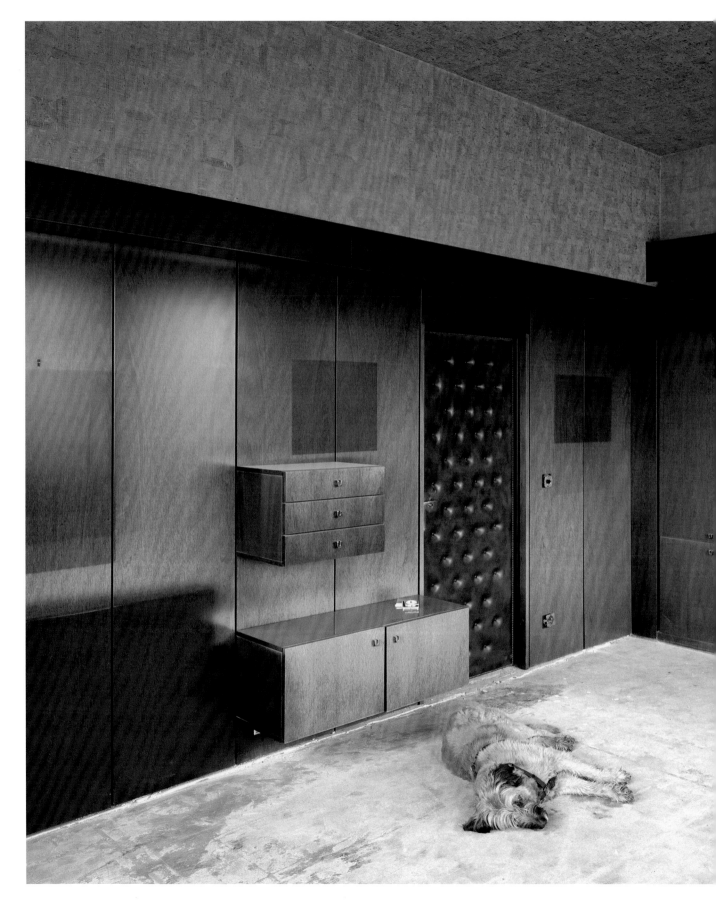

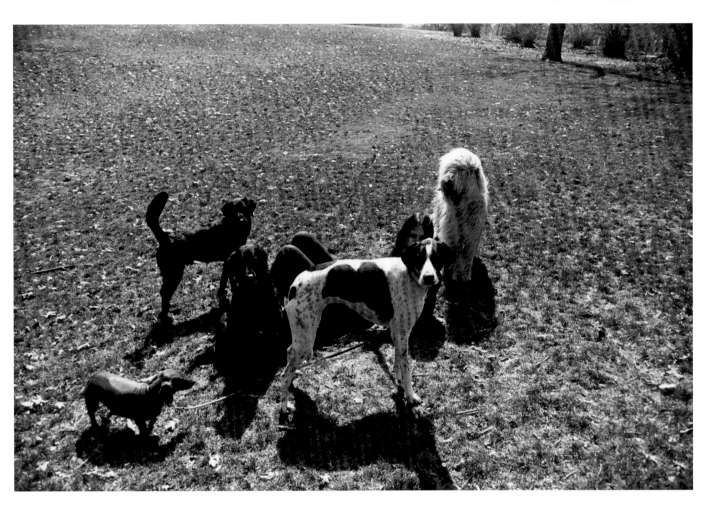

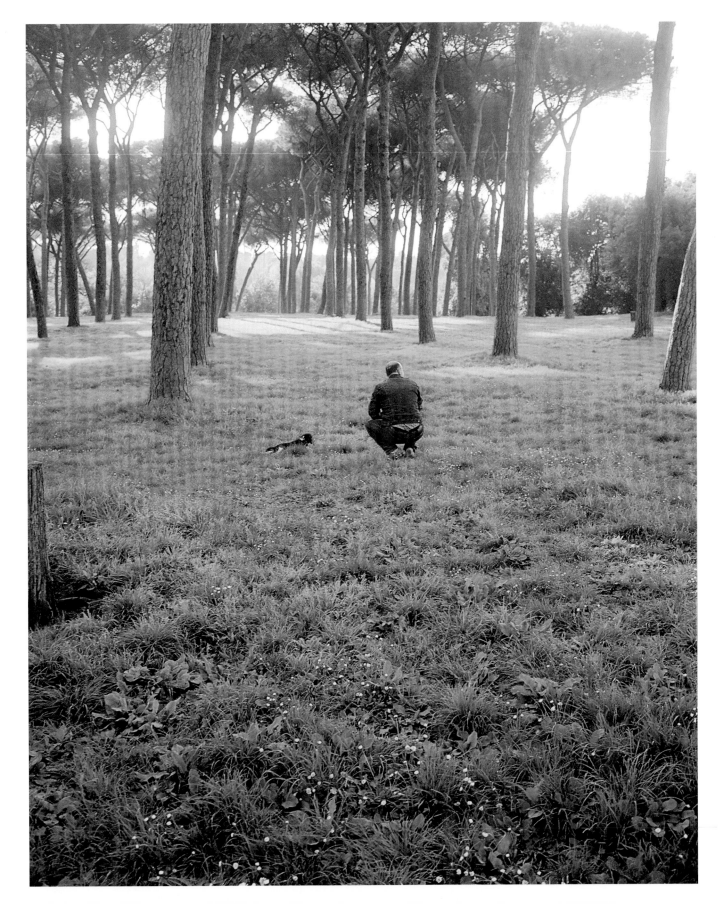

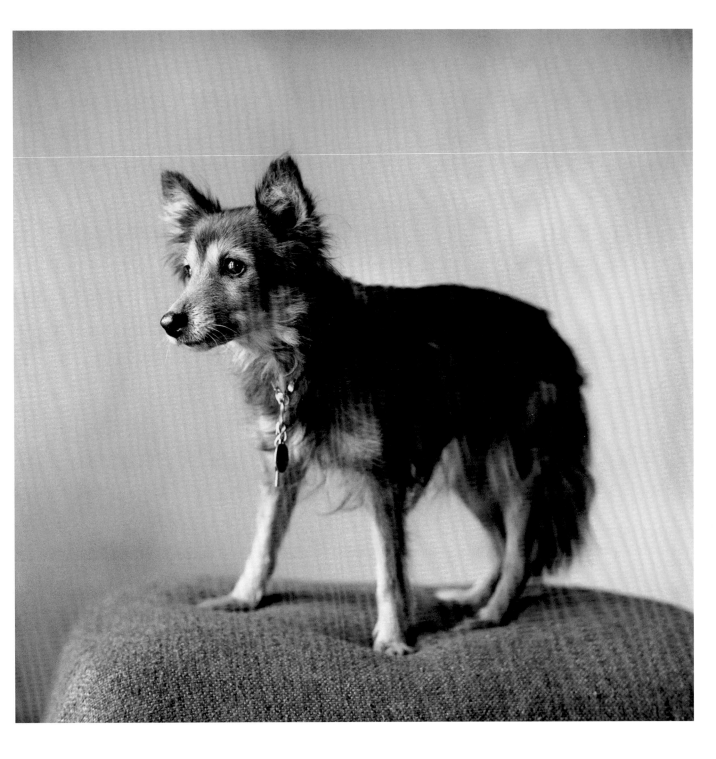

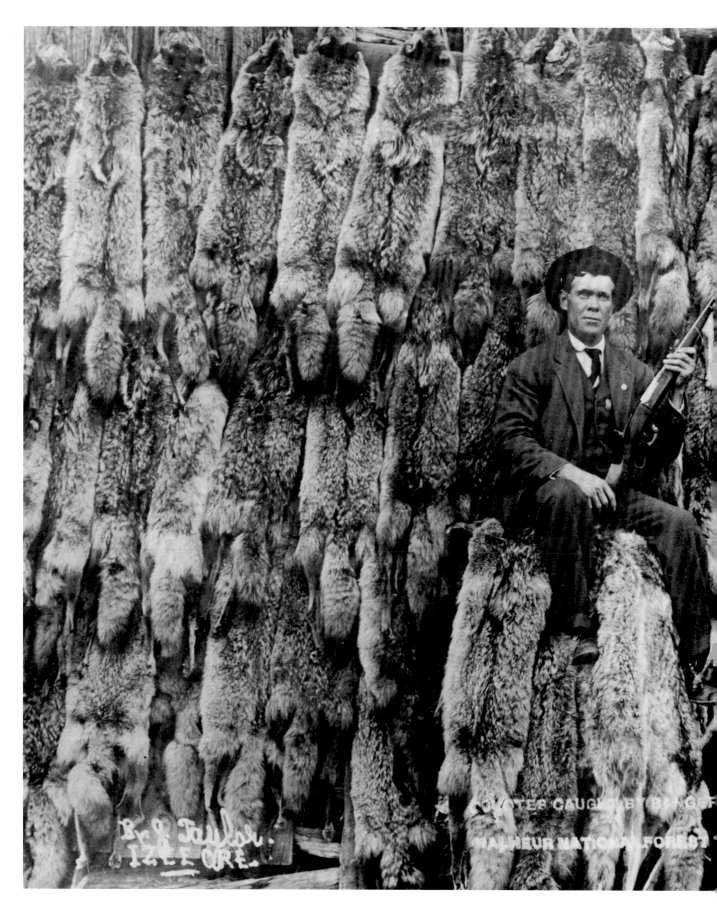

COYOTES CAUGHT BY RANGER

MALHEUR NATIONAL FOREST

R. J. Taylor.
IZEE ORE.

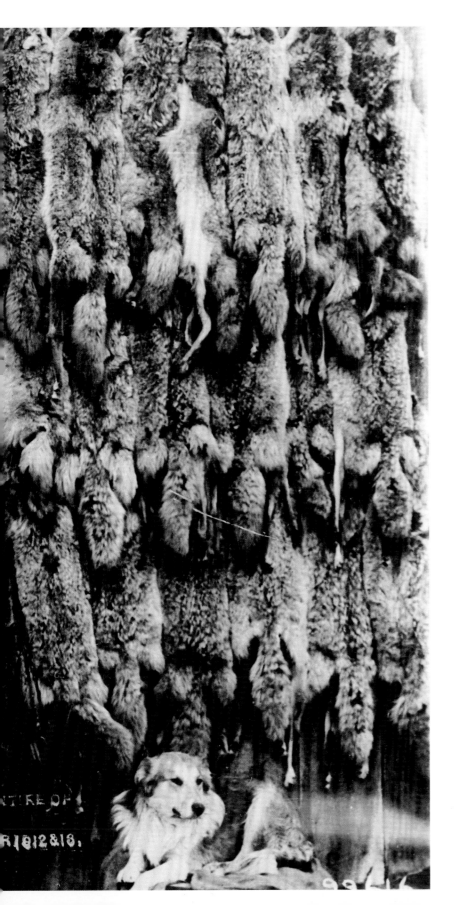

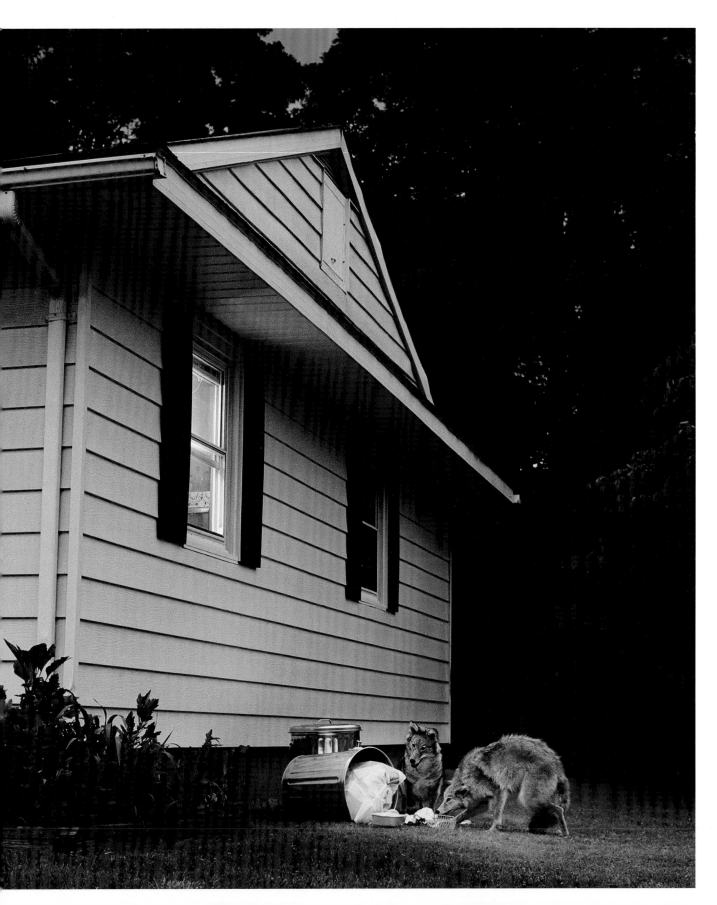

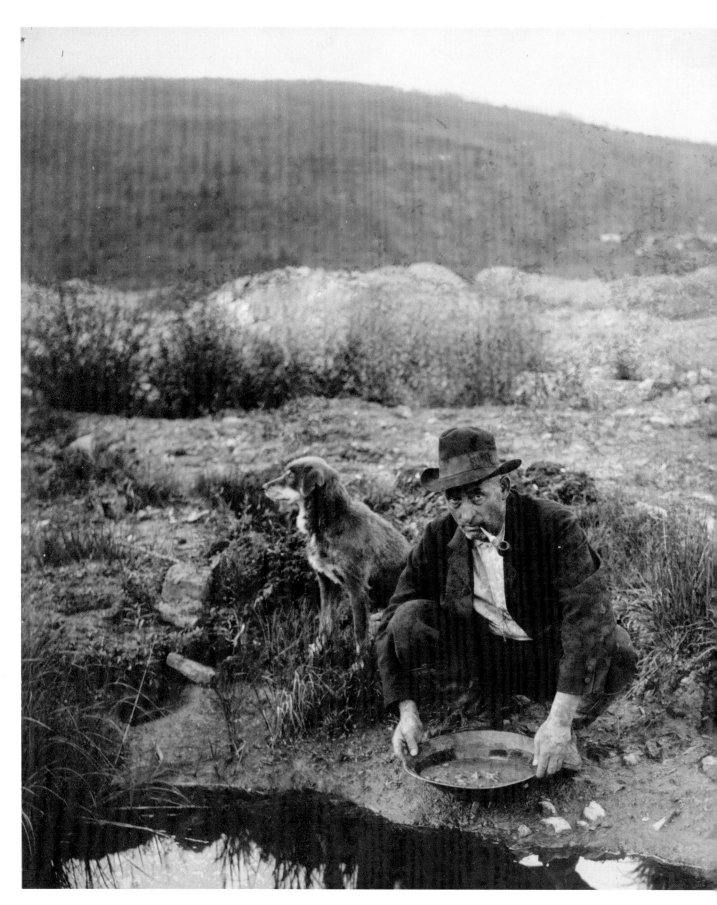

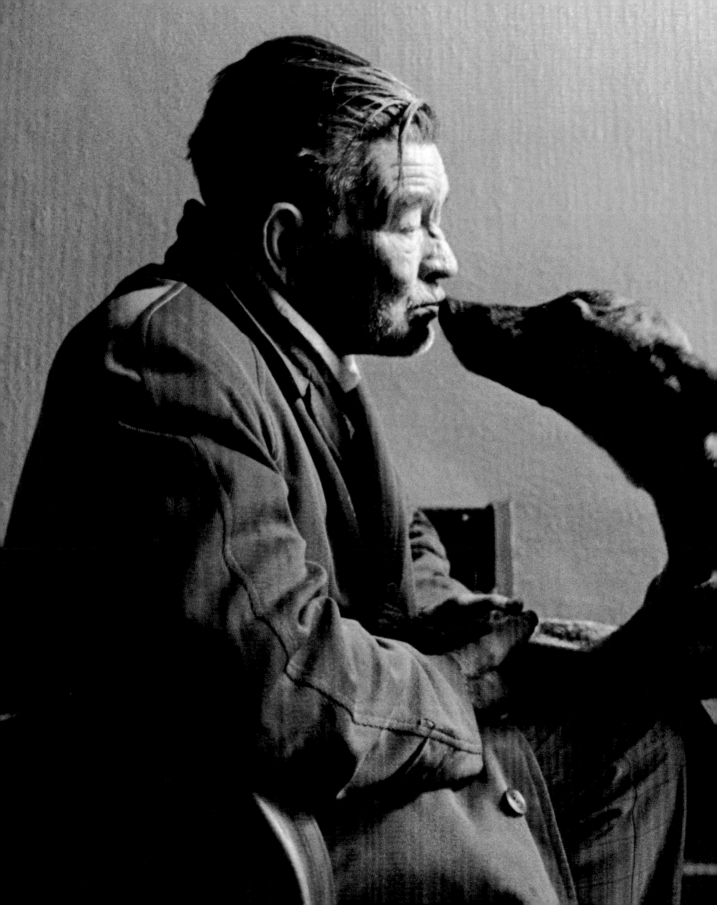

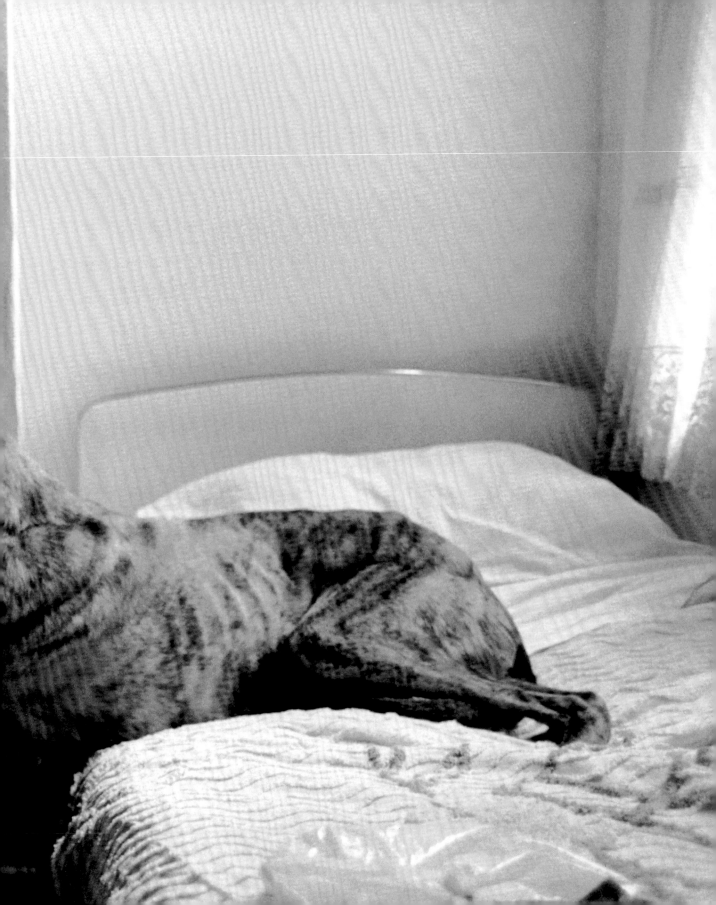

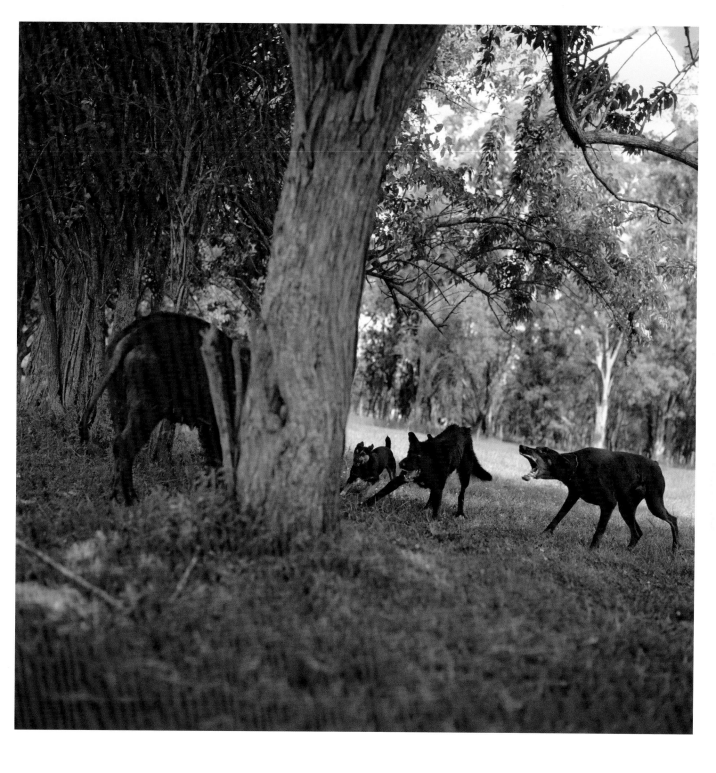

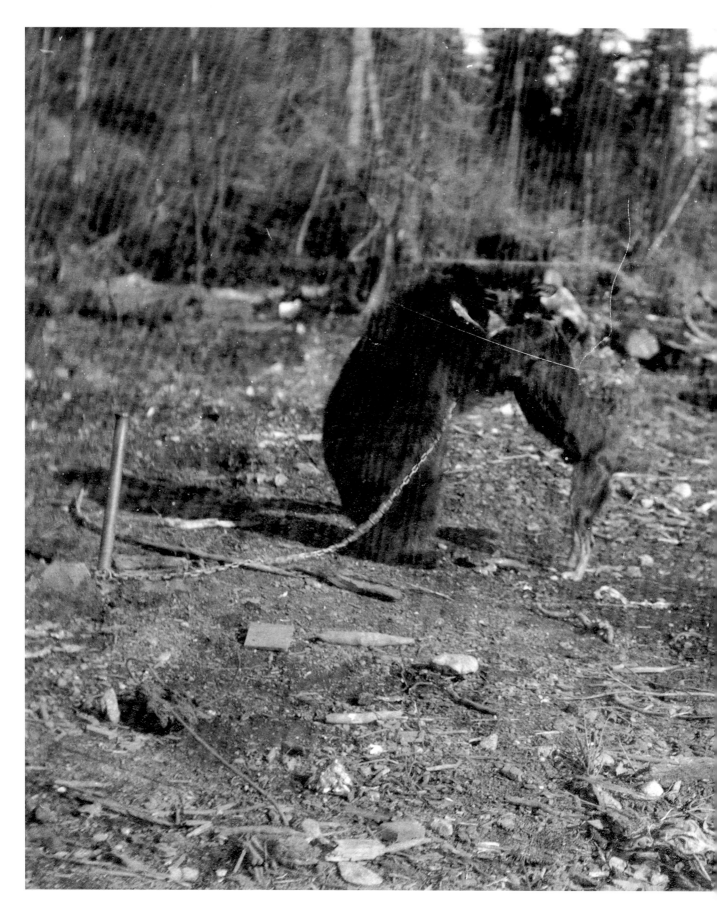

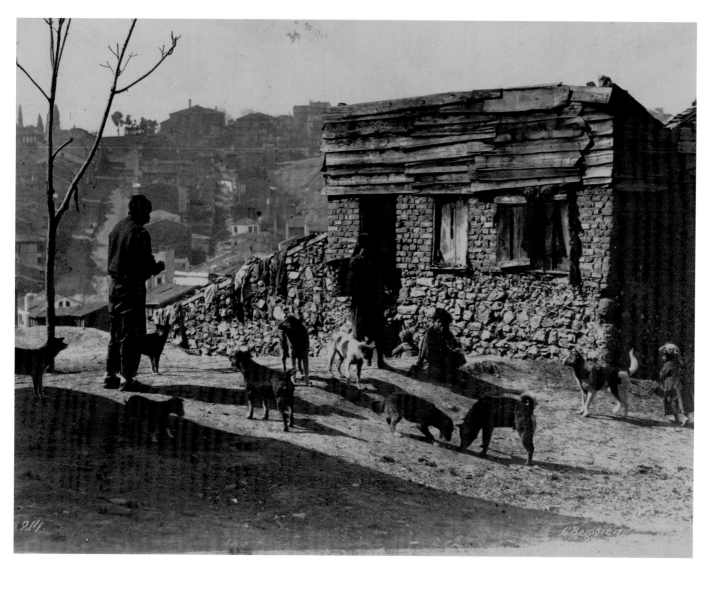

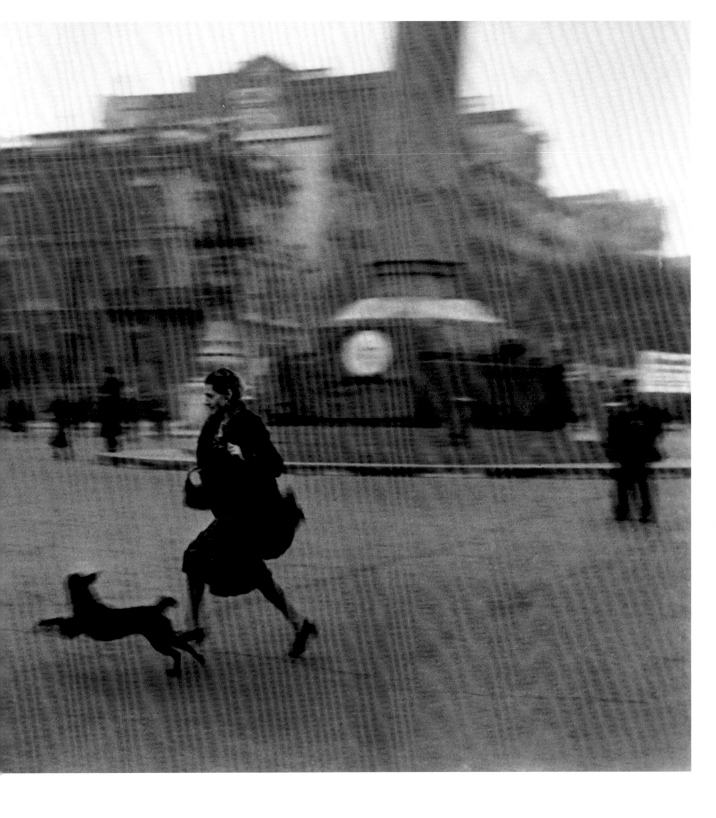

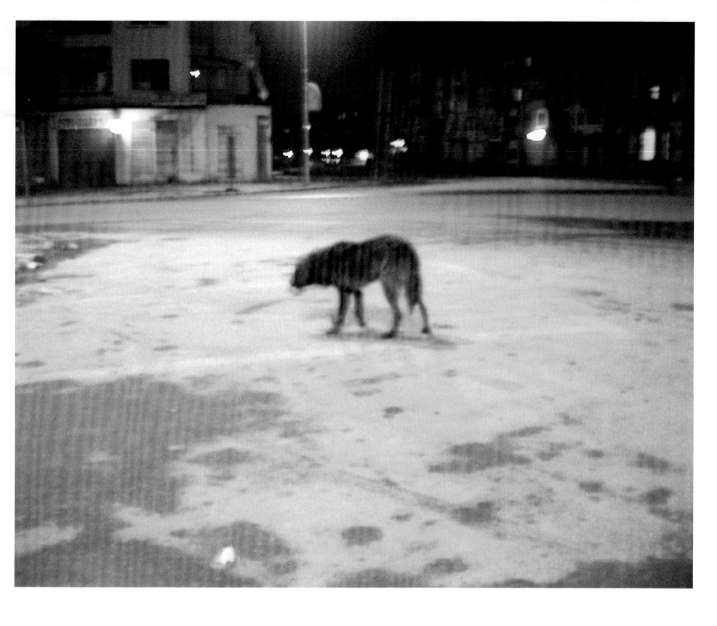

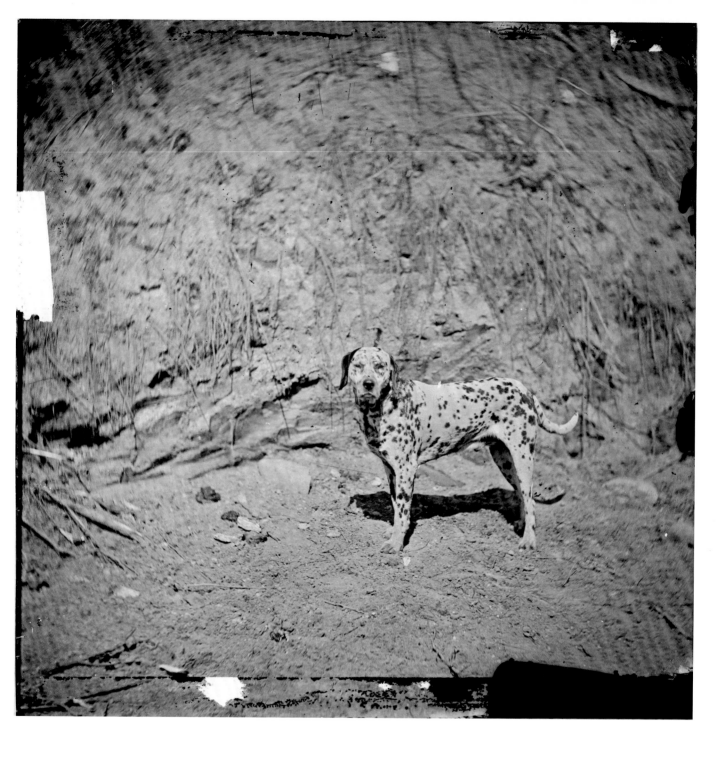

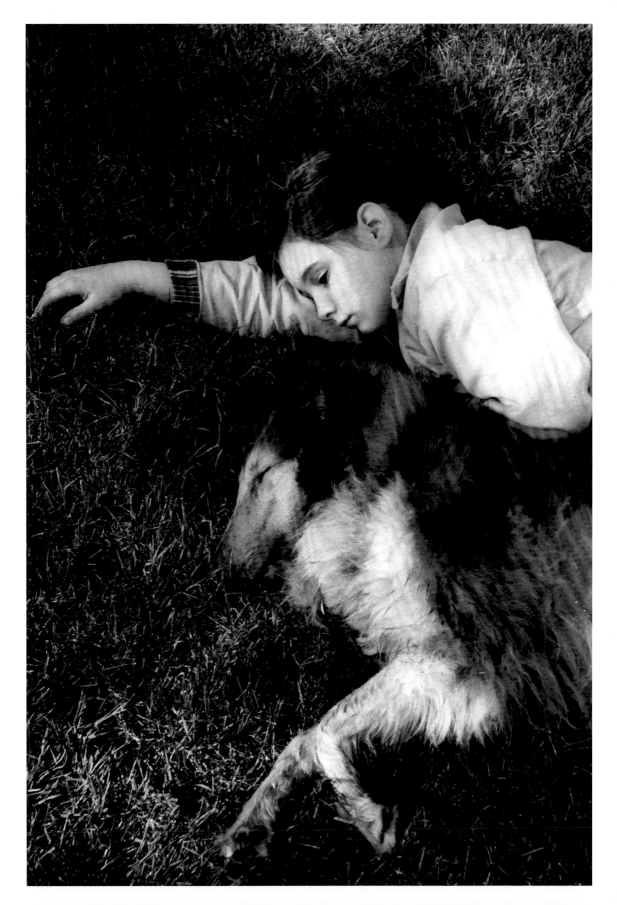

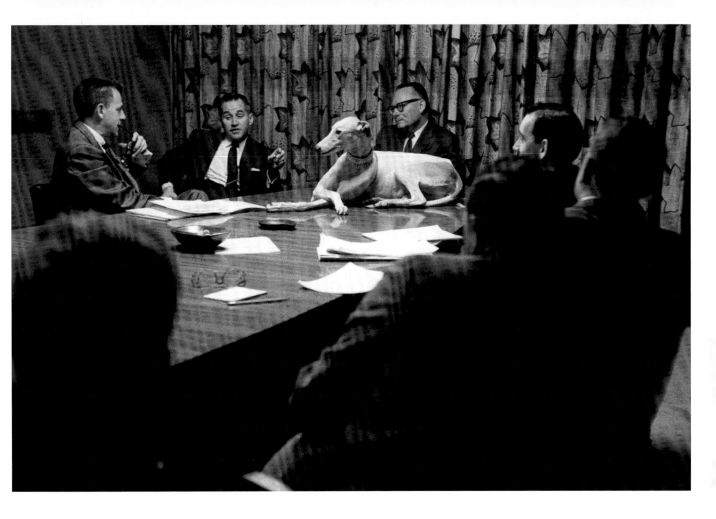

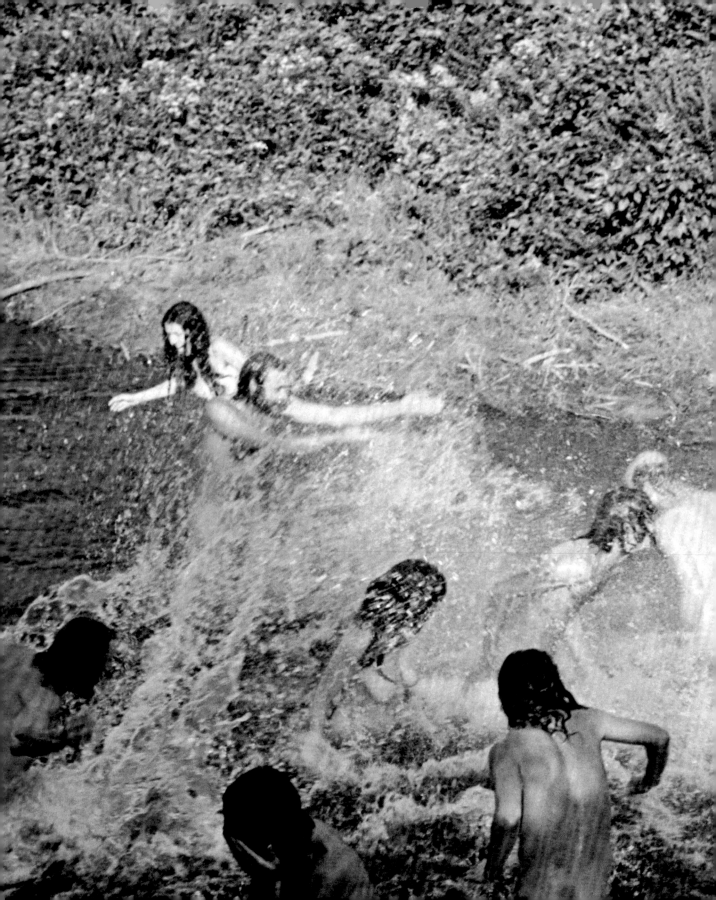

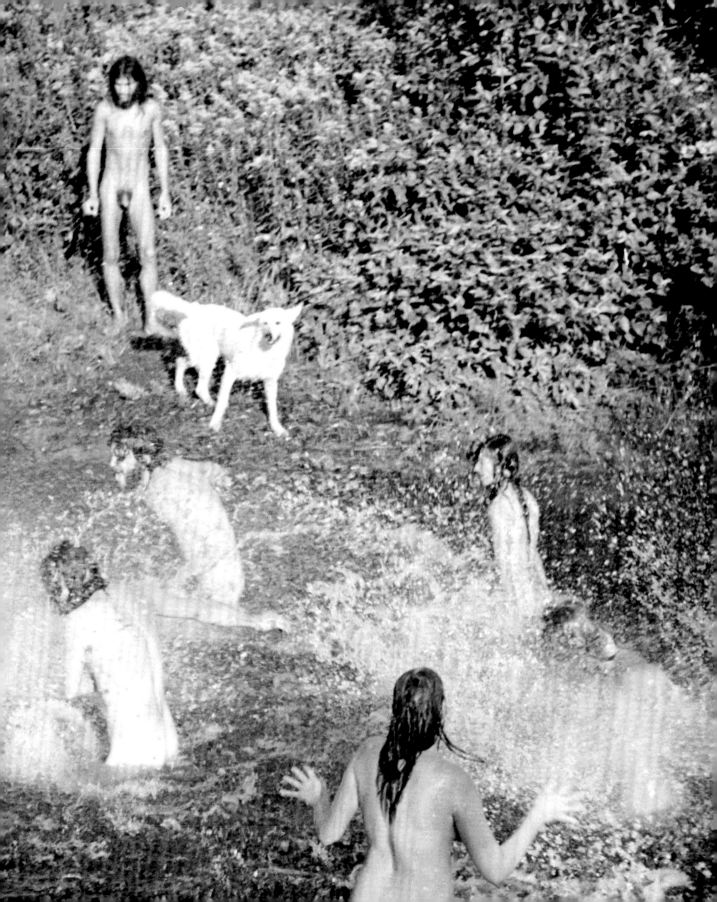

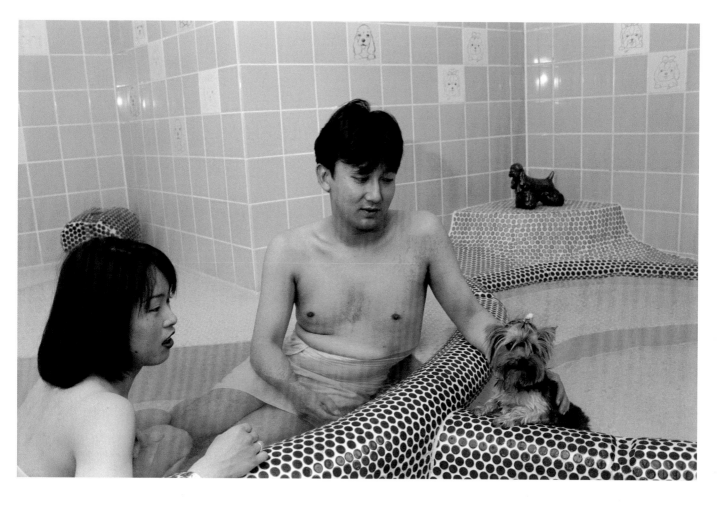

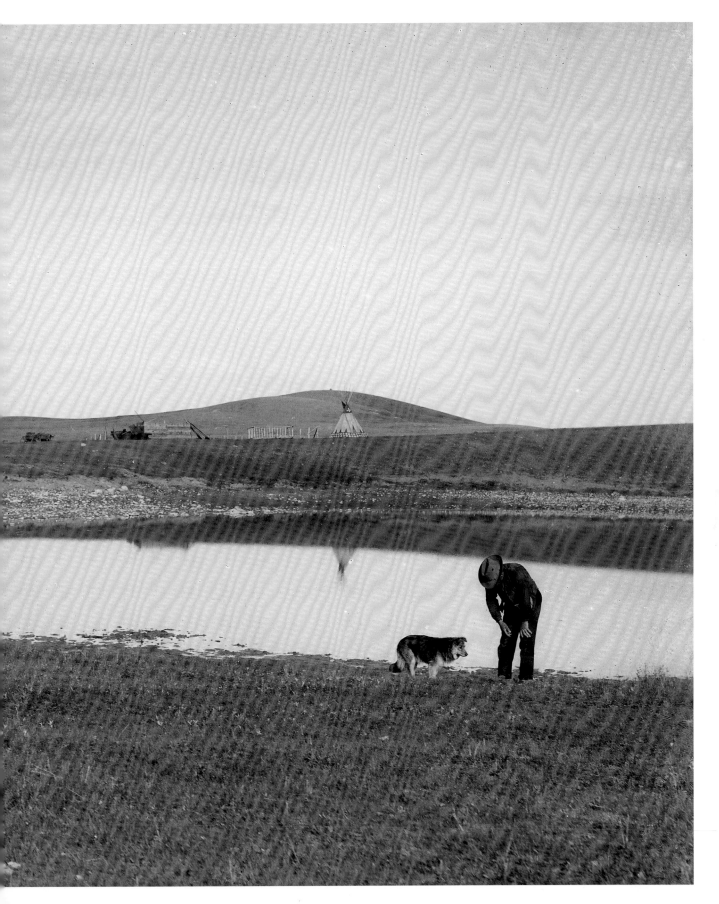

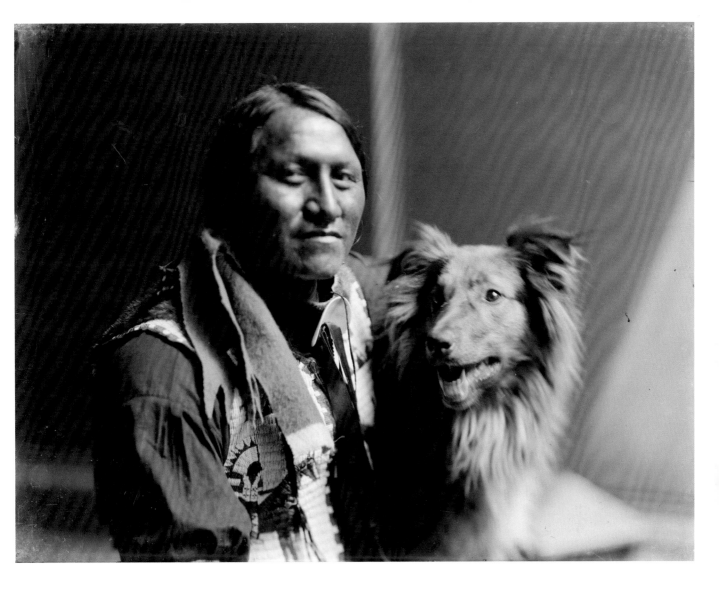

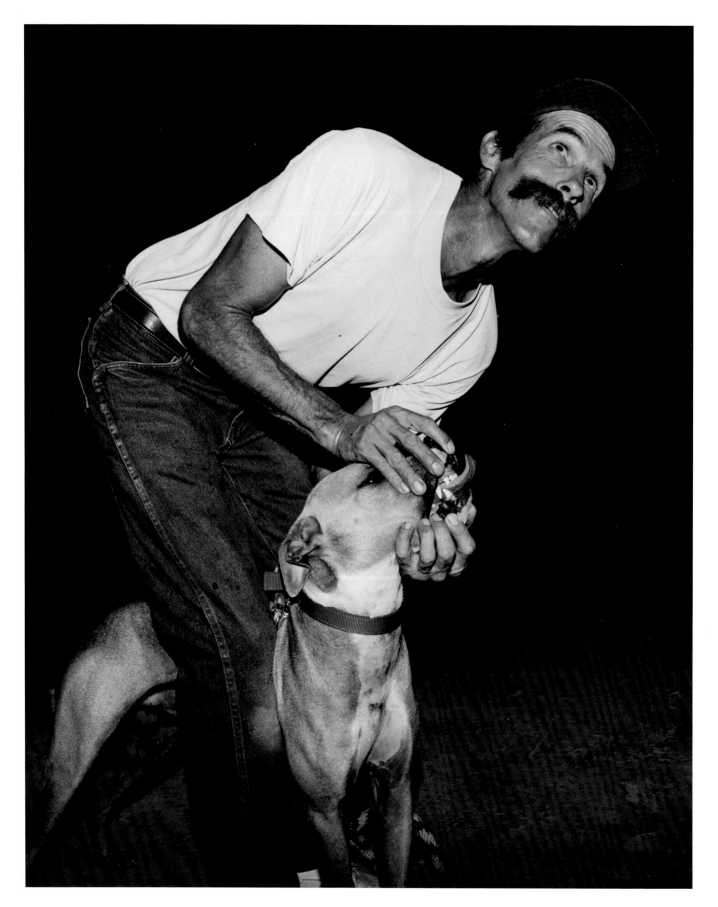

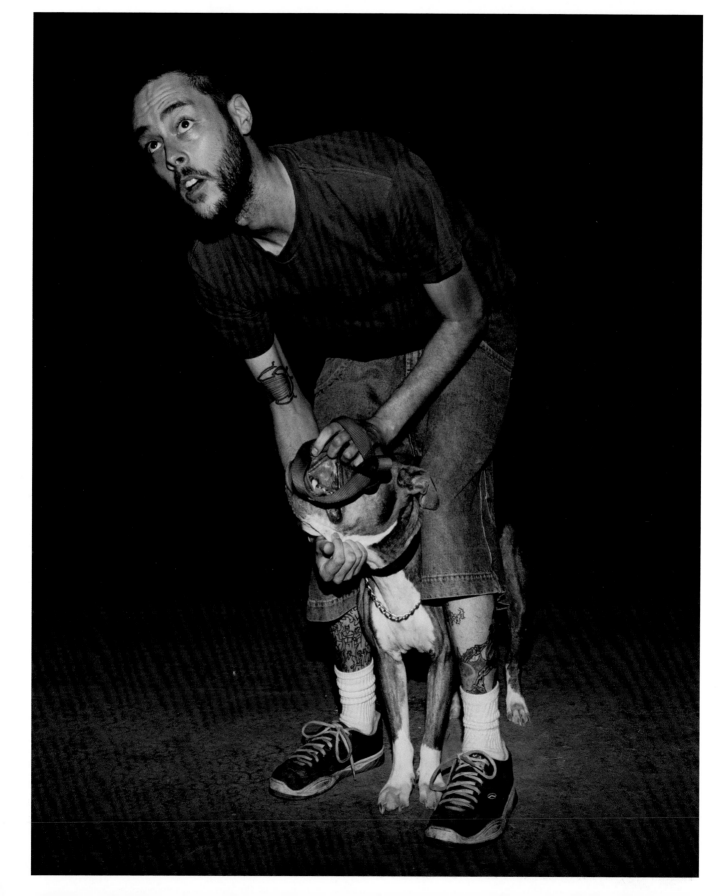

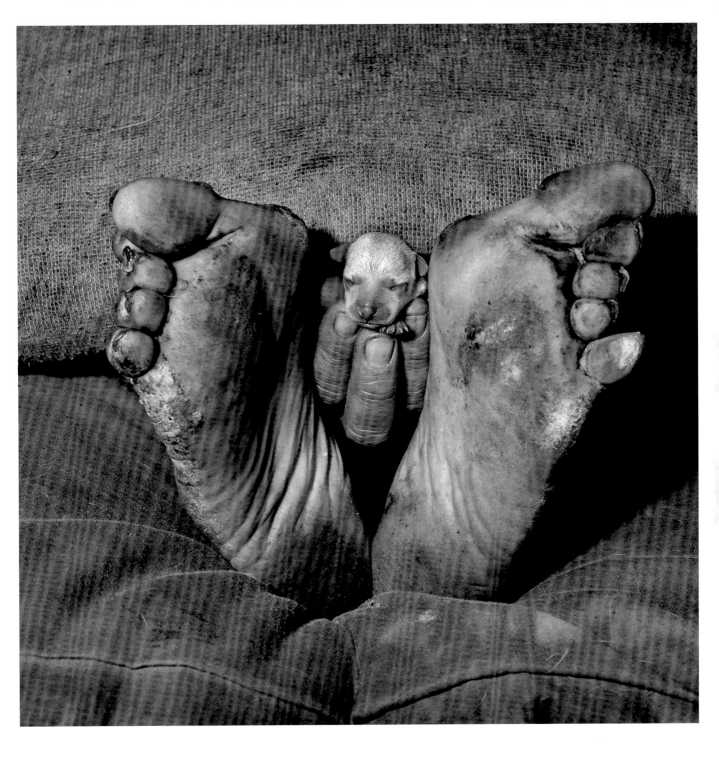

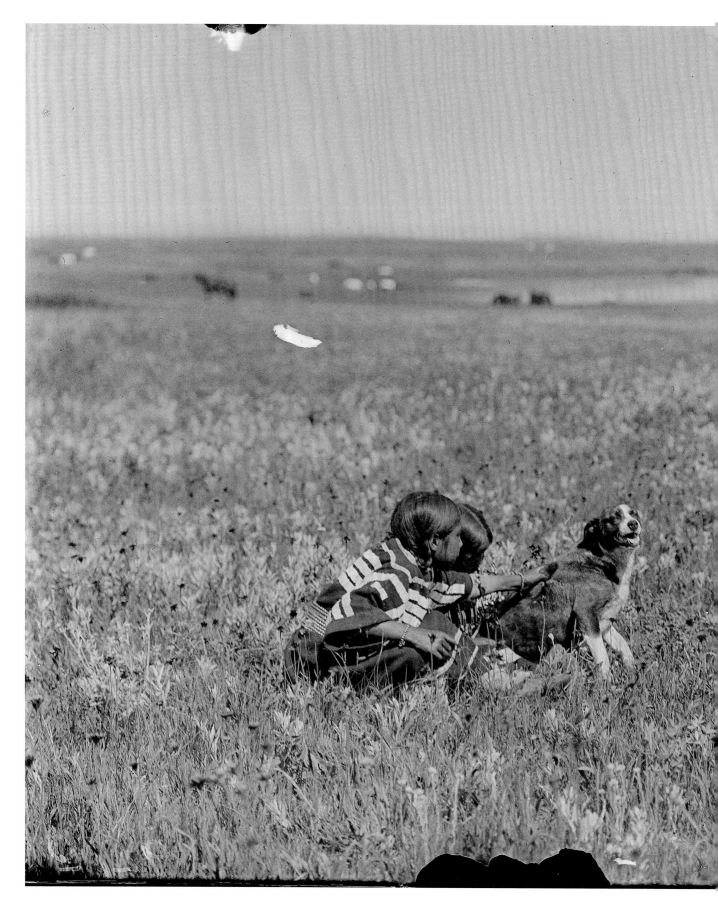

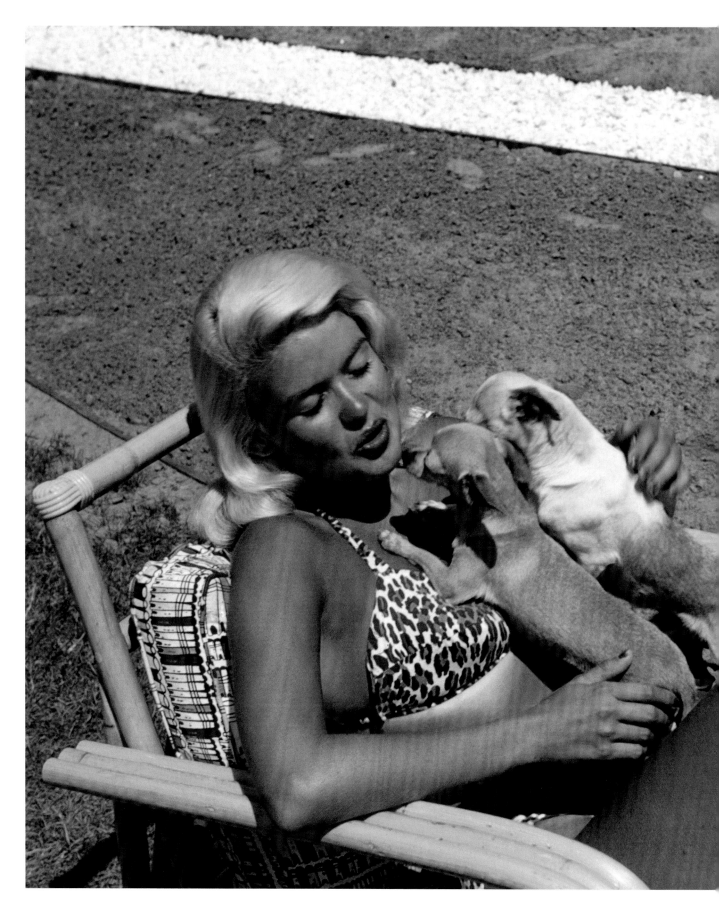

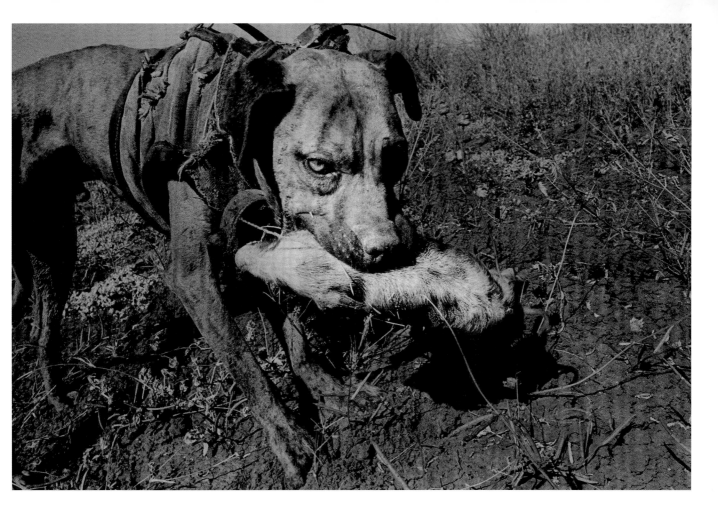

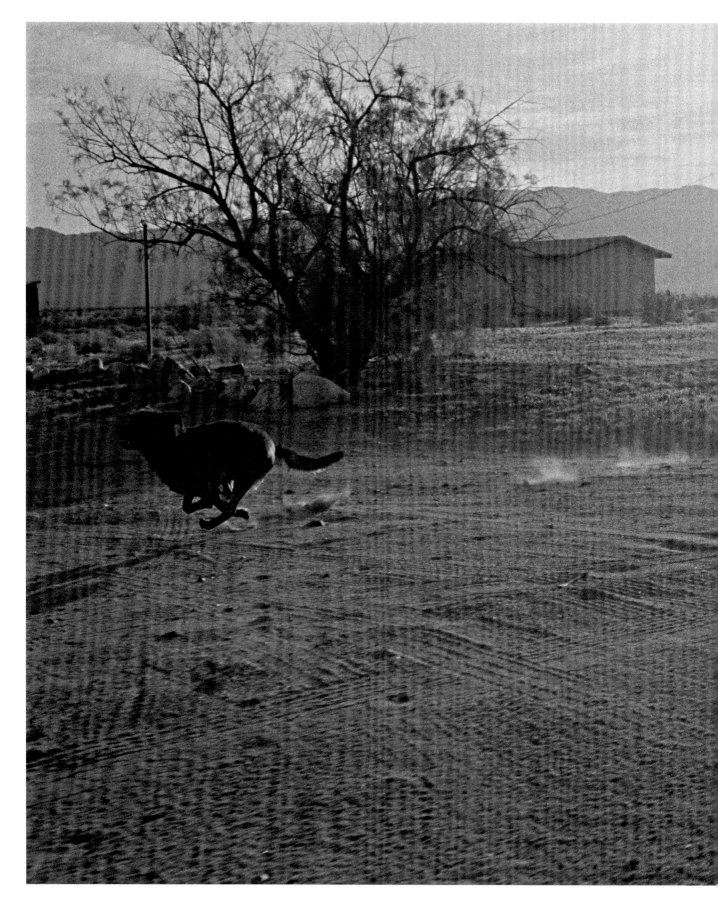

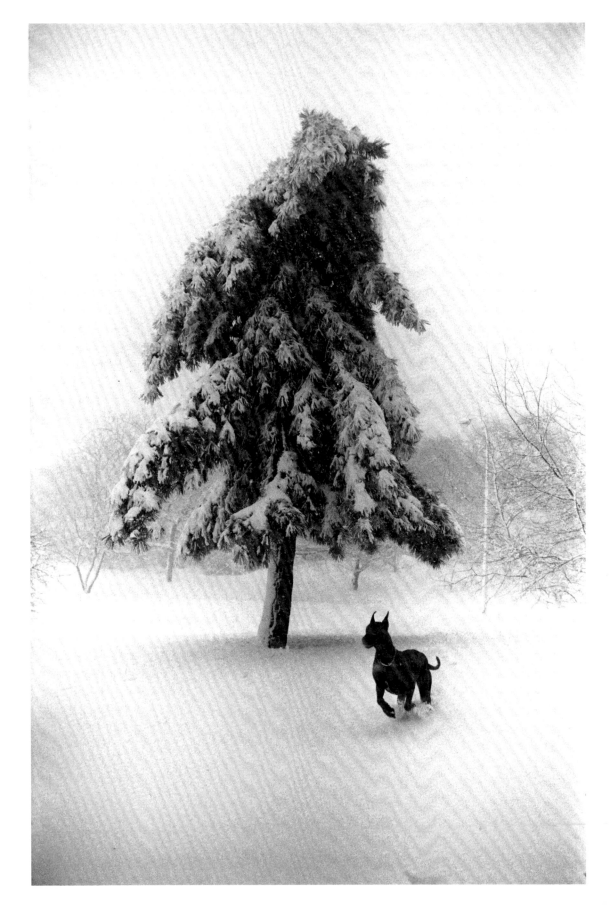

69669-COPYRIGHT 1905, BY
DETROIT PHOTOGRAPHIC CO.

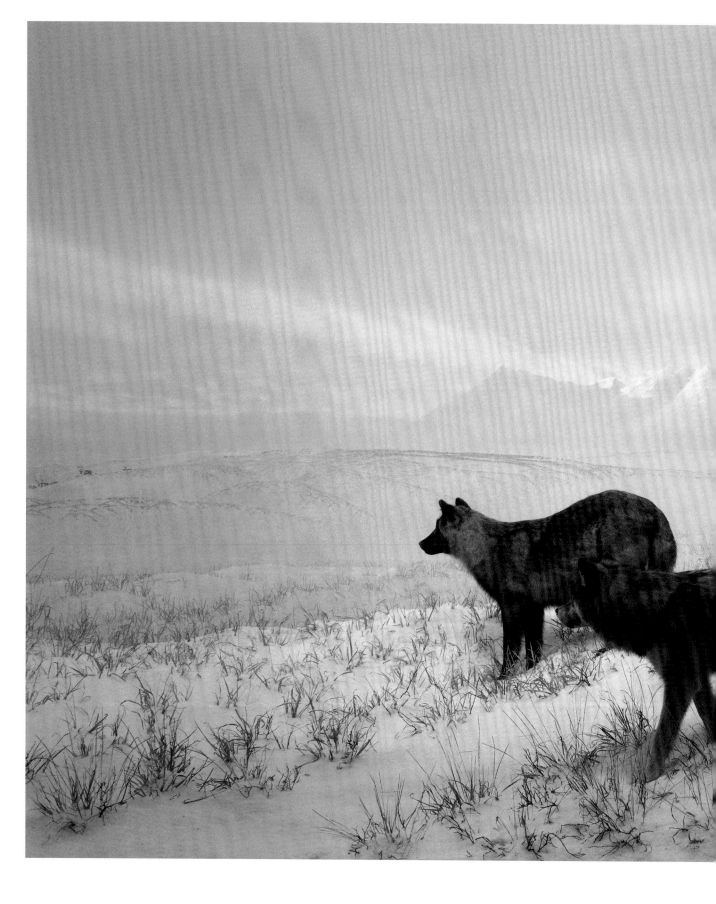

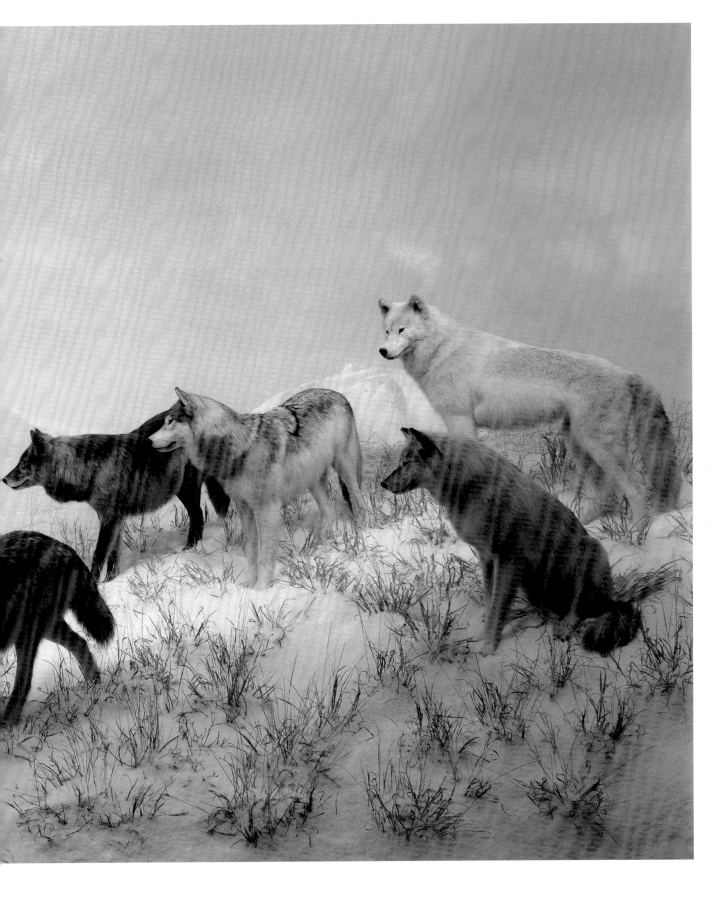

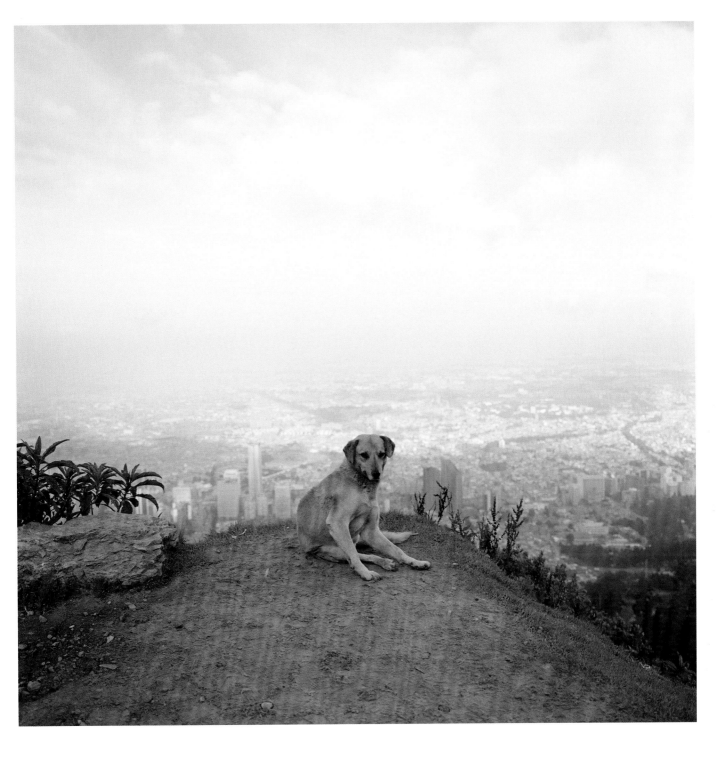

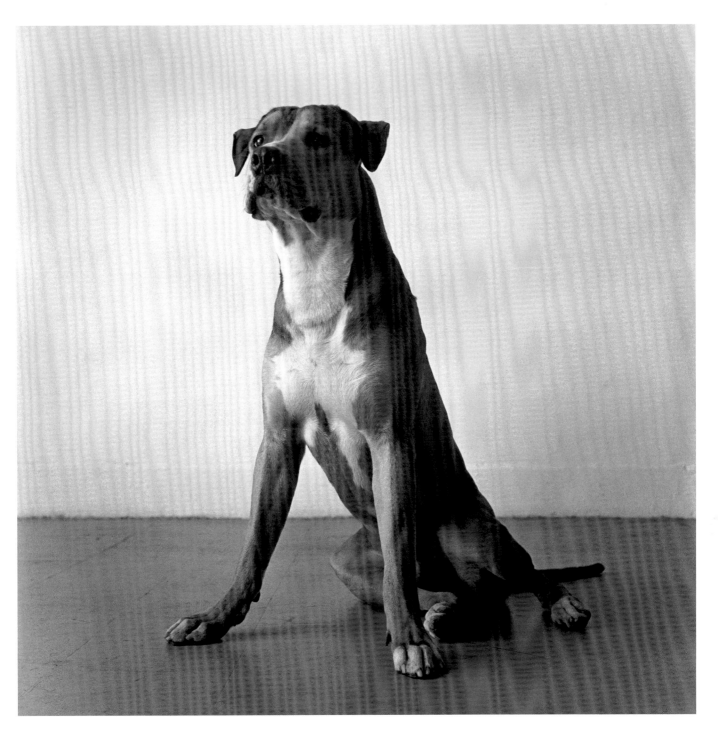

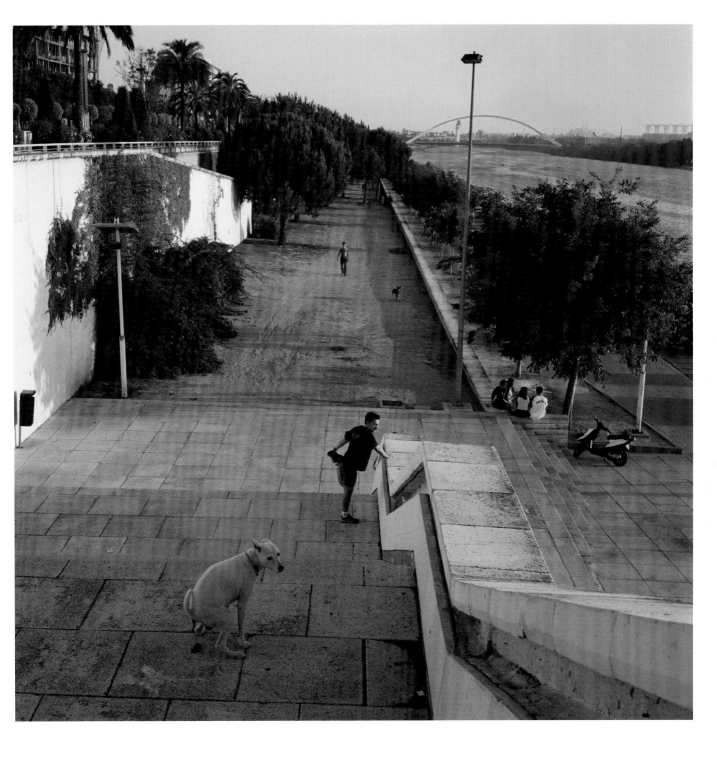

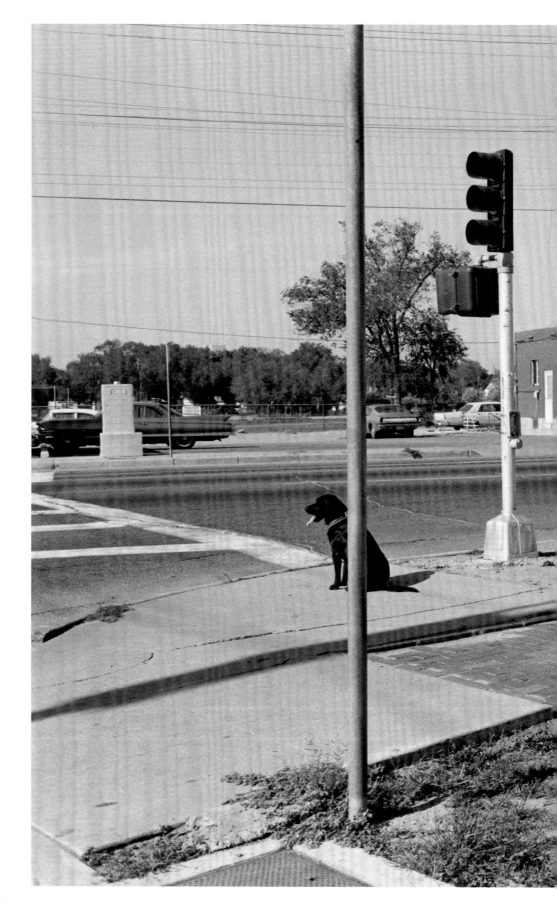

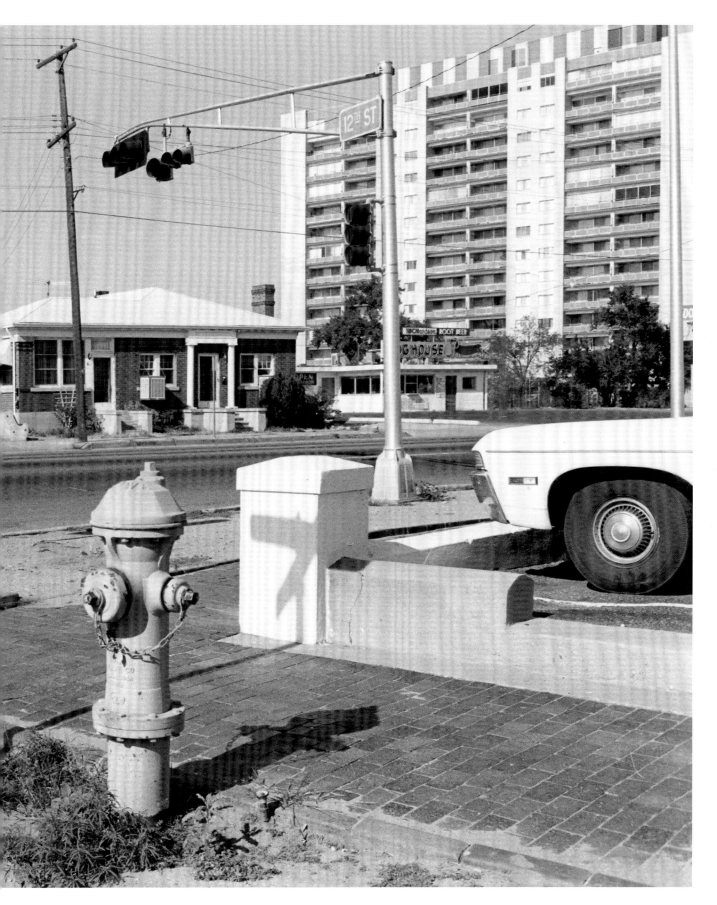

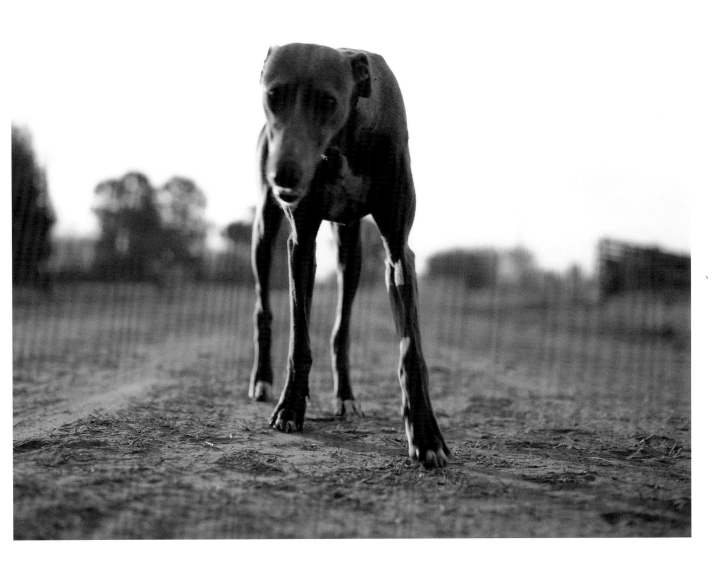

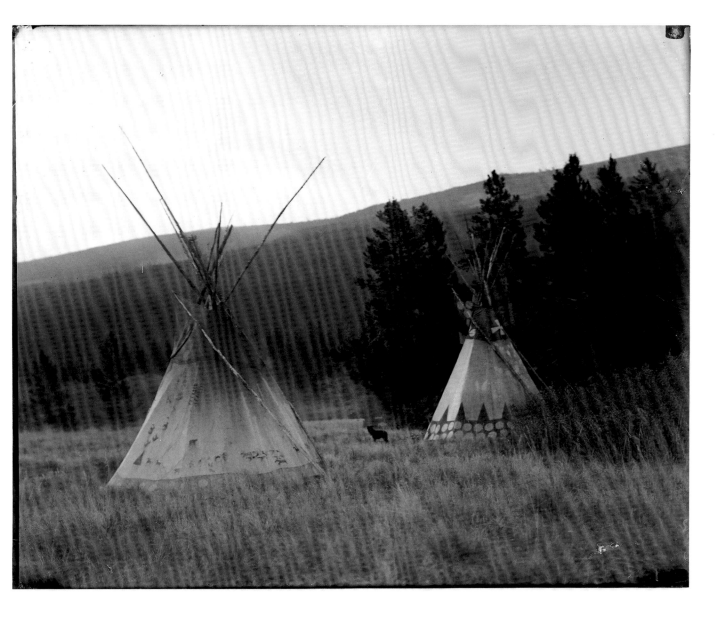

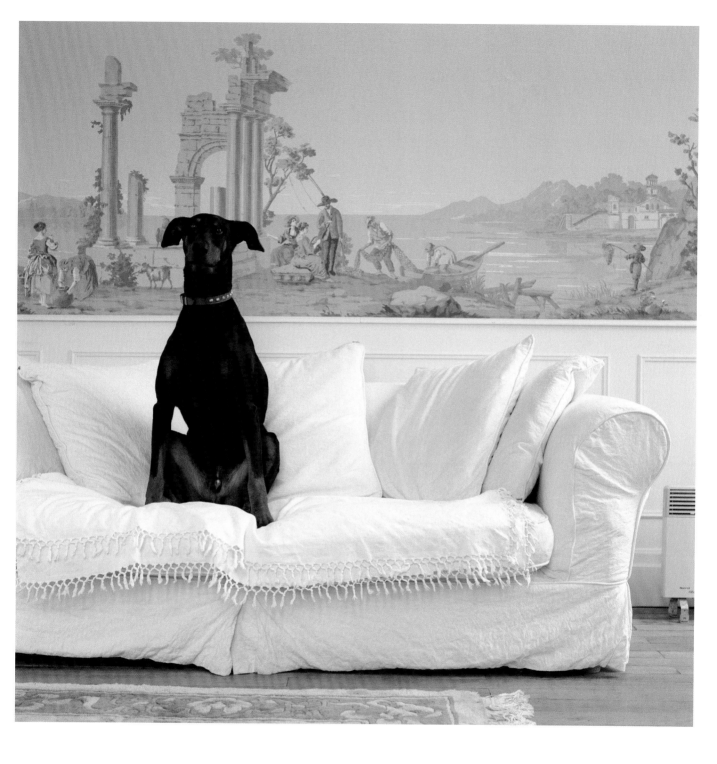

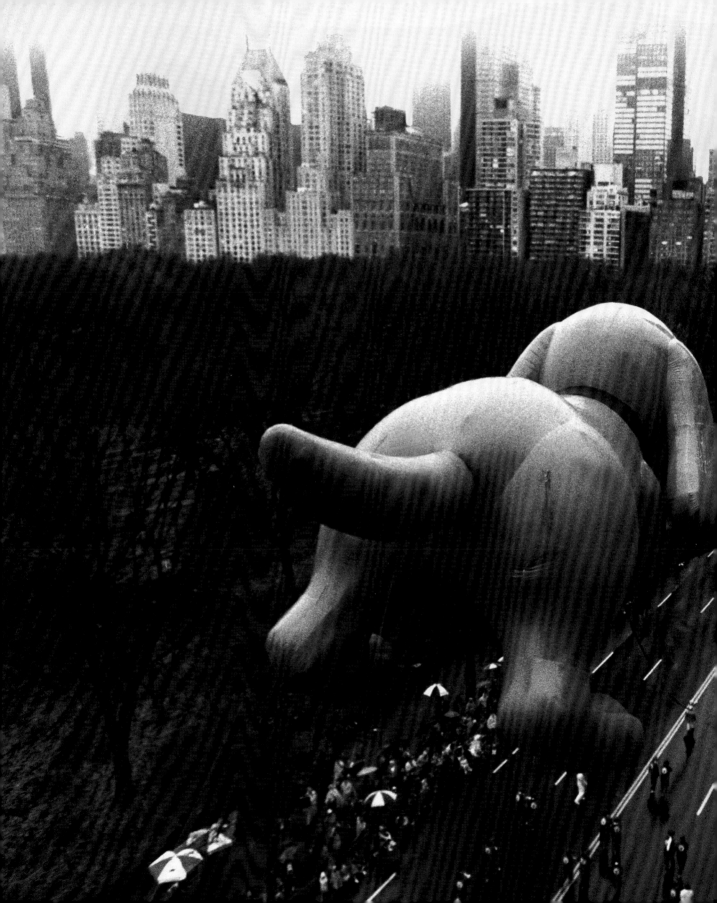

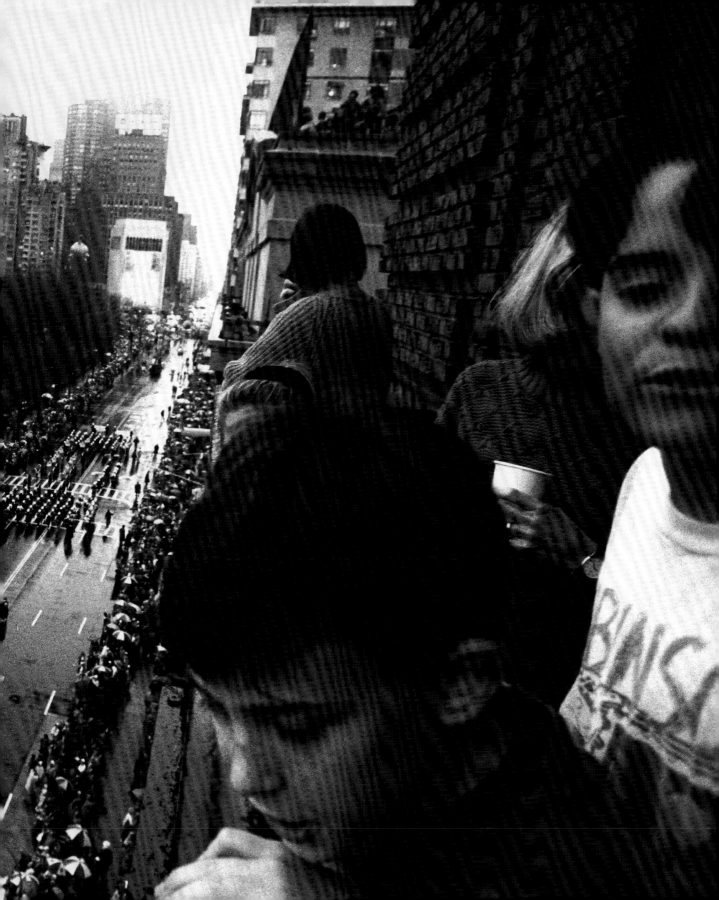

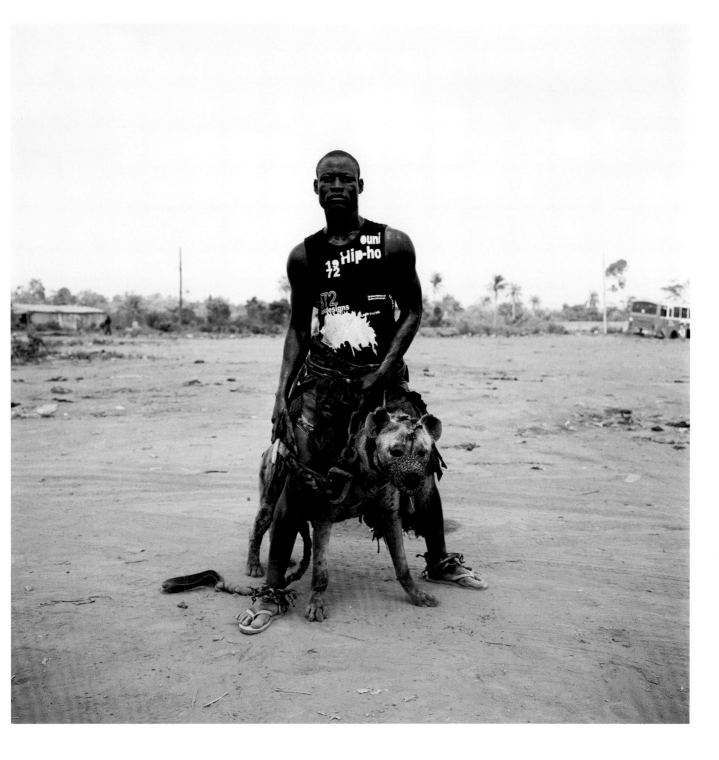

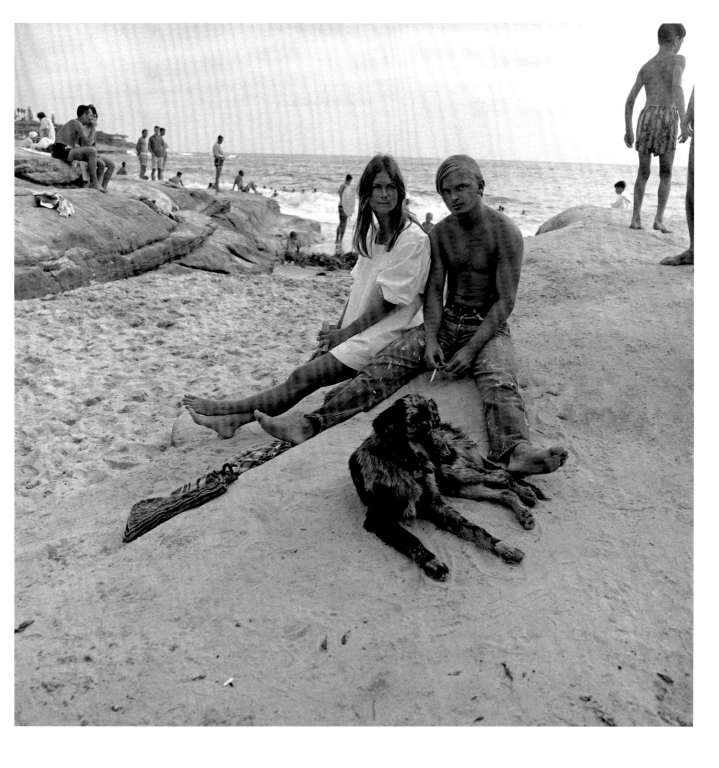

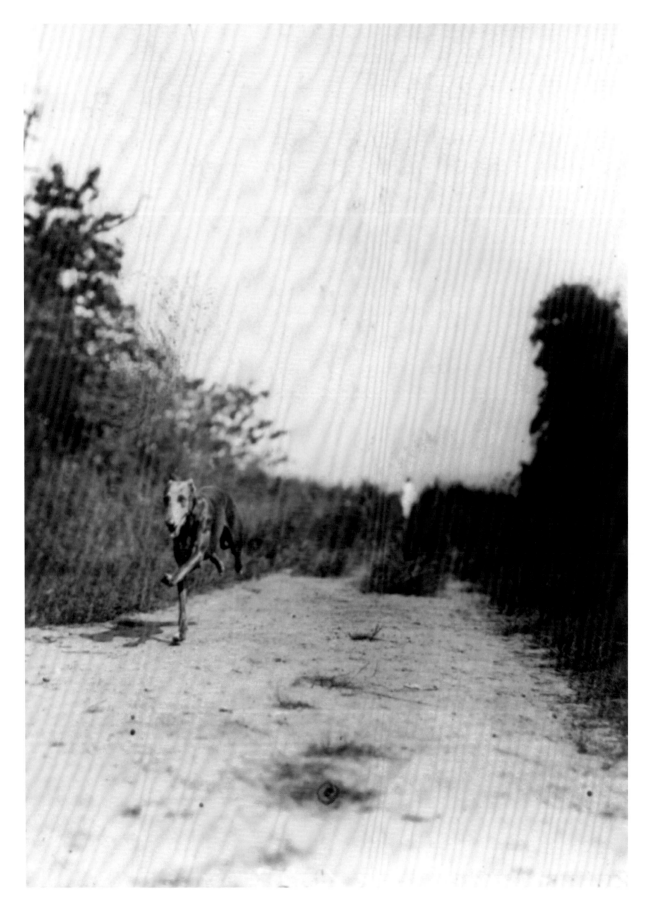

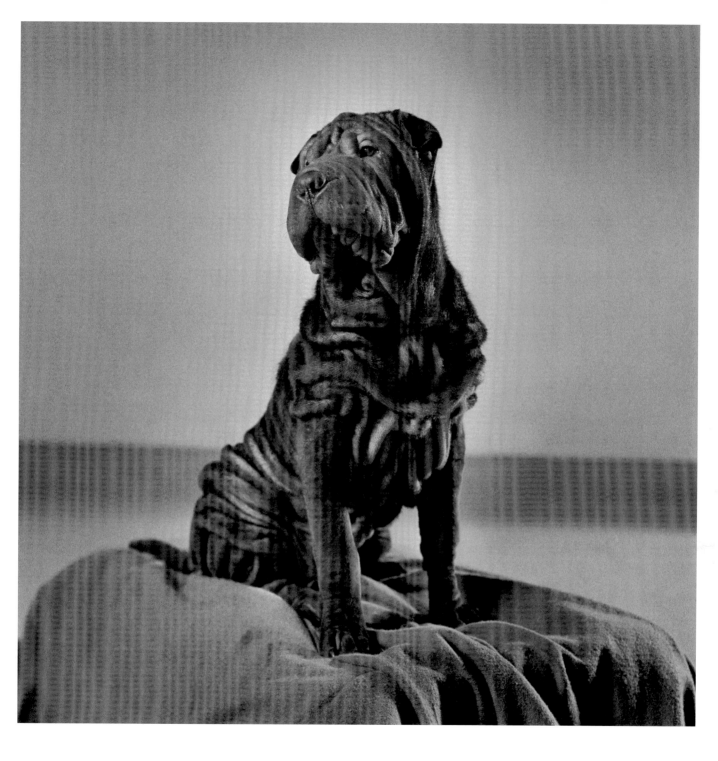

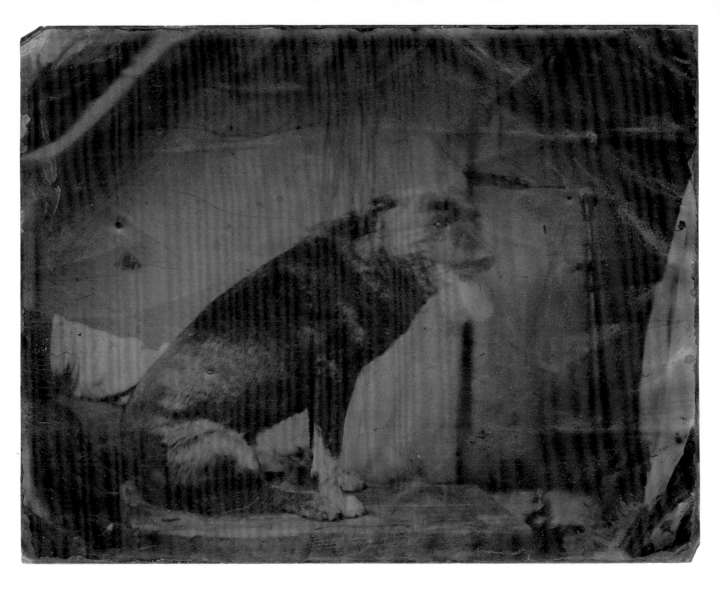

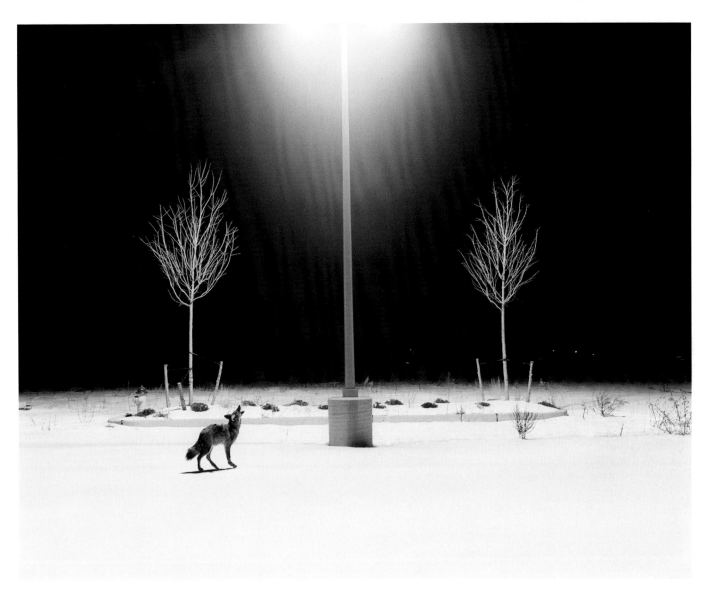

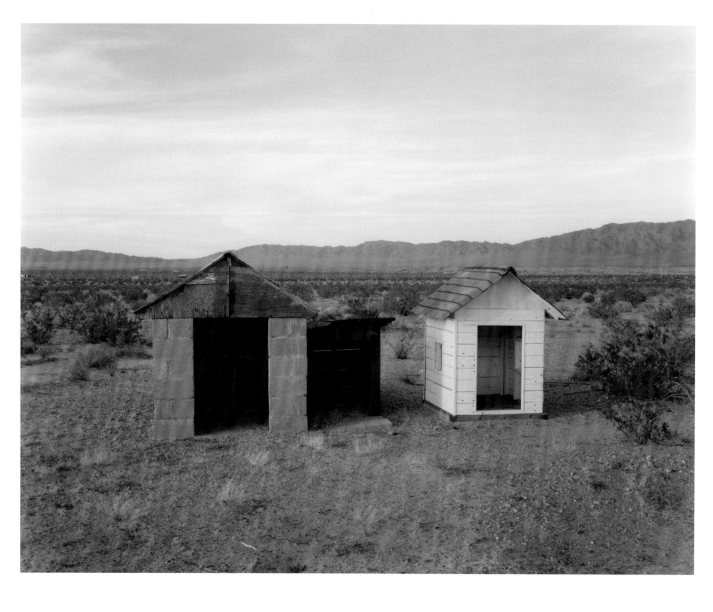

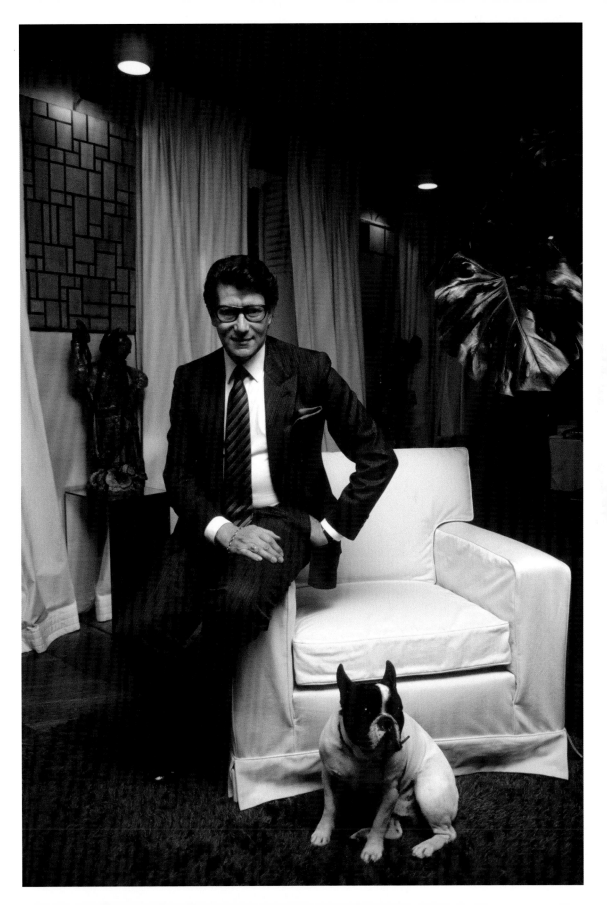

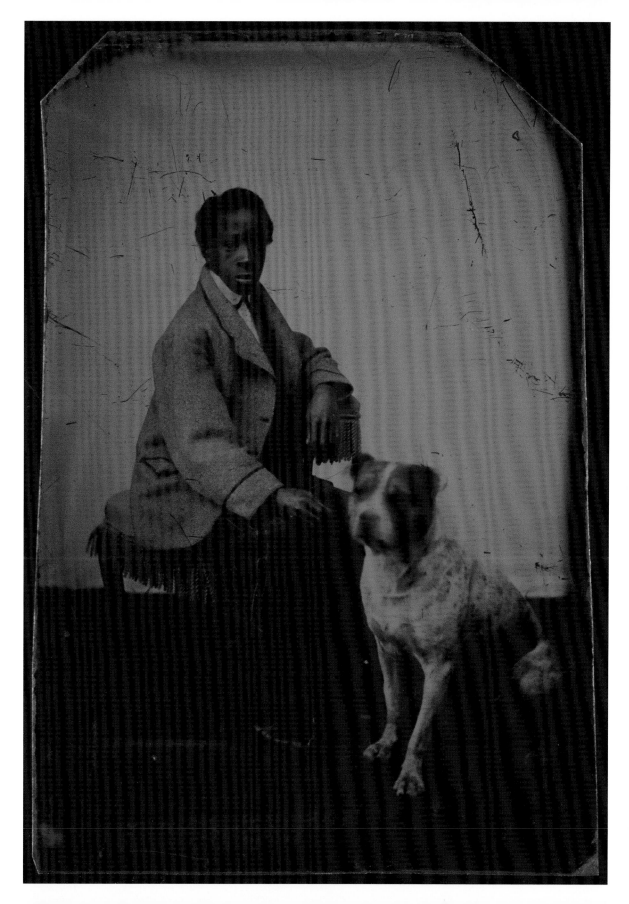

LIST OF WORKS

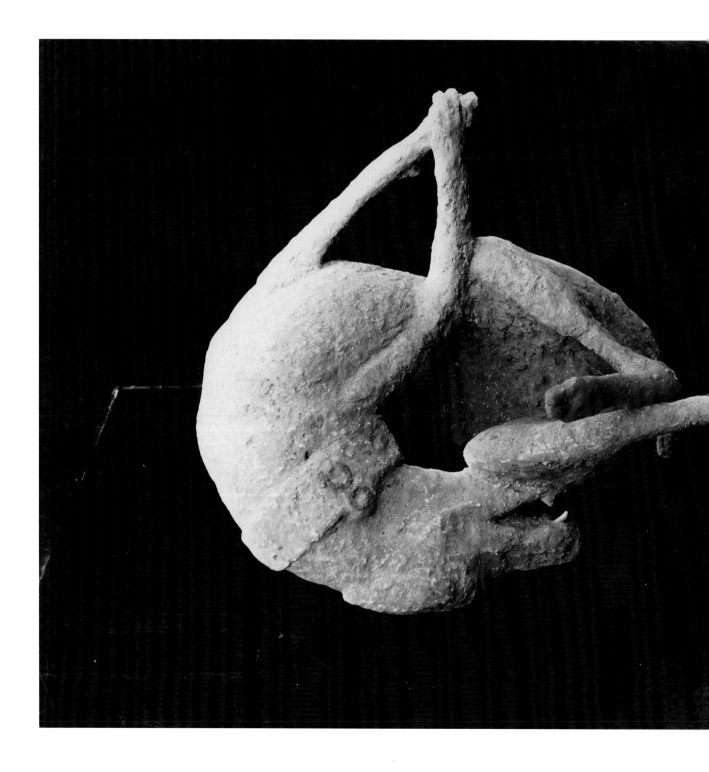

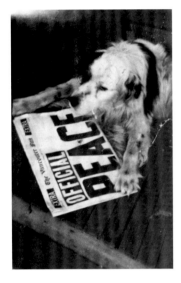

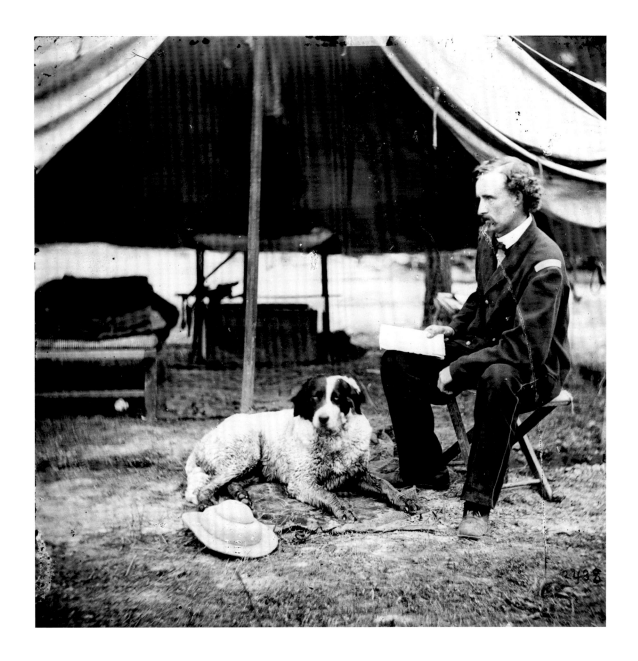

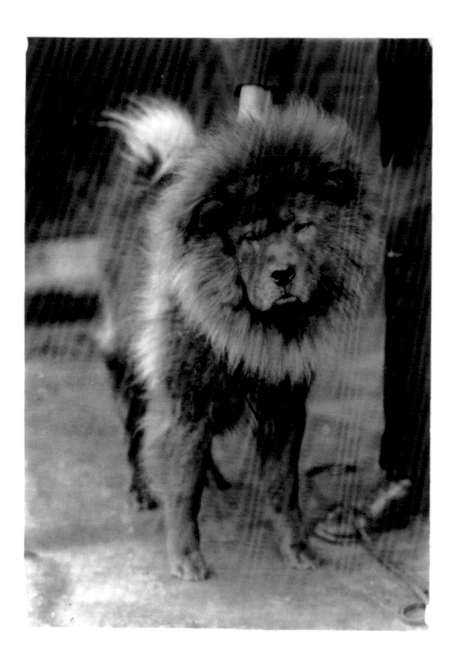

I am His Highness' dog at Kew;
Pray tell me, sir, whose dog are you?

—EPIGRAM ON THE COLLAR OF A DOG GIVEN TO FREDERICK,
PRINCE OF WALES BY ALEXANDER POPE

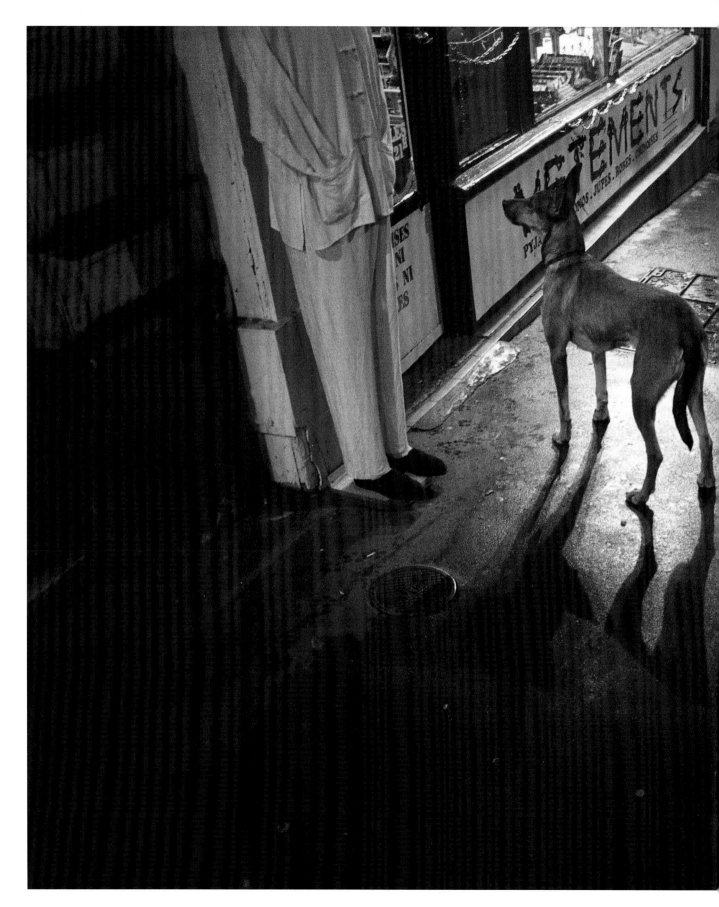

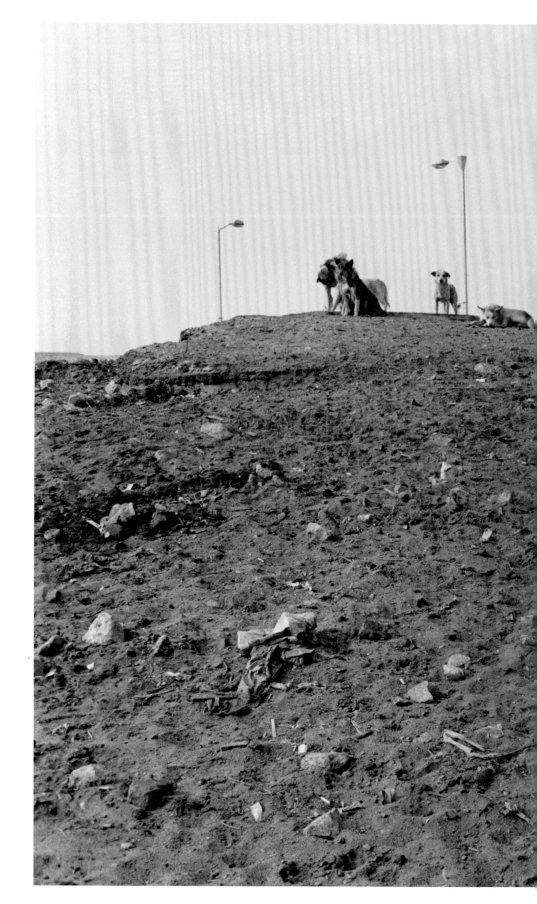

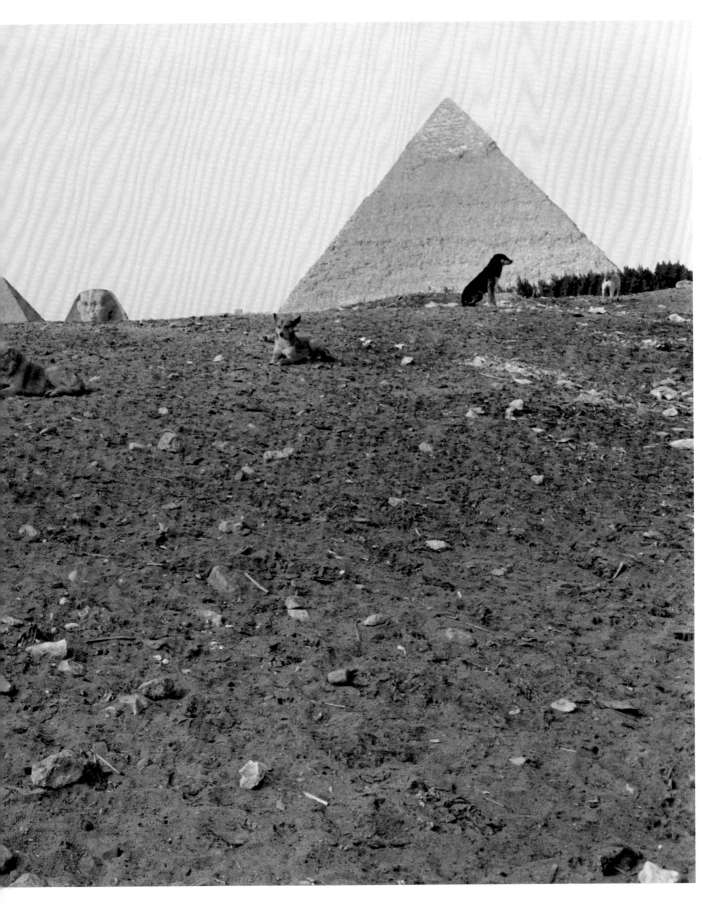

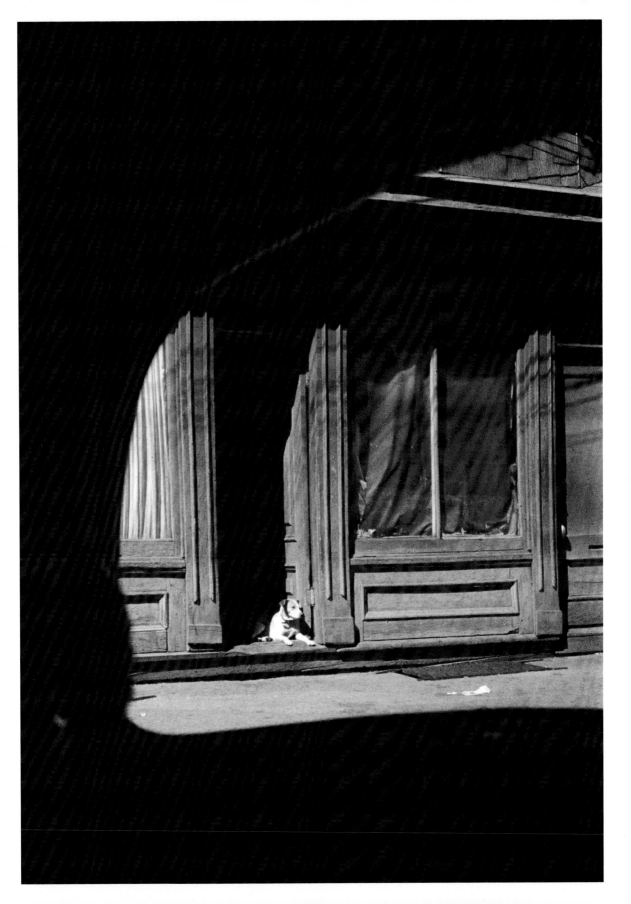

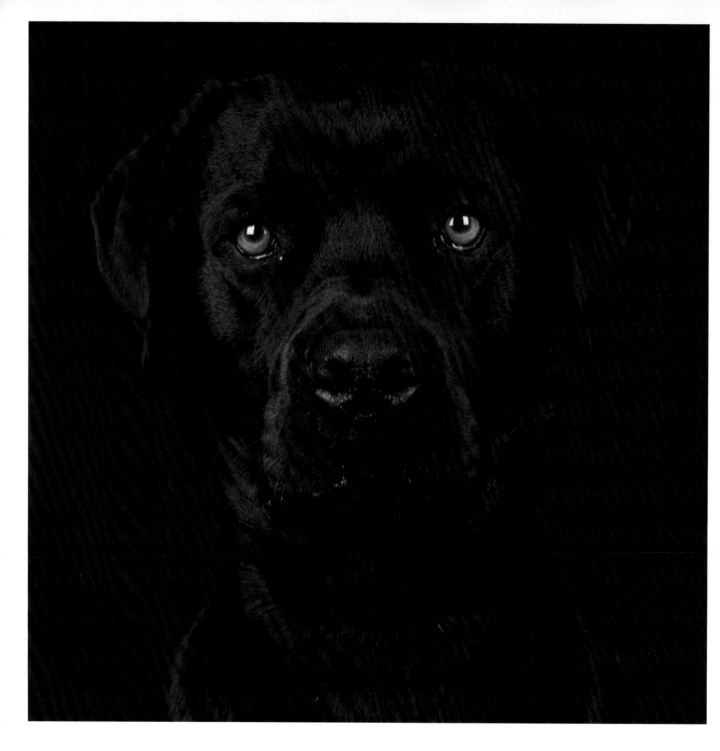